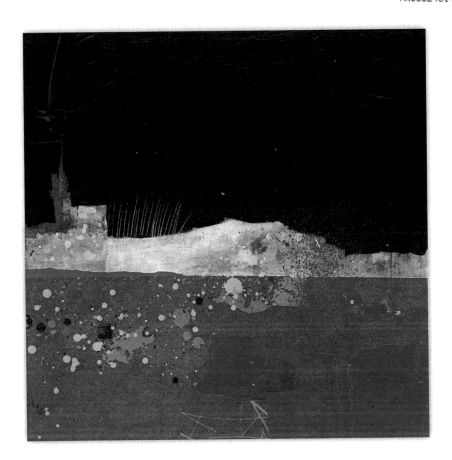

ABSTRACTPAINTING

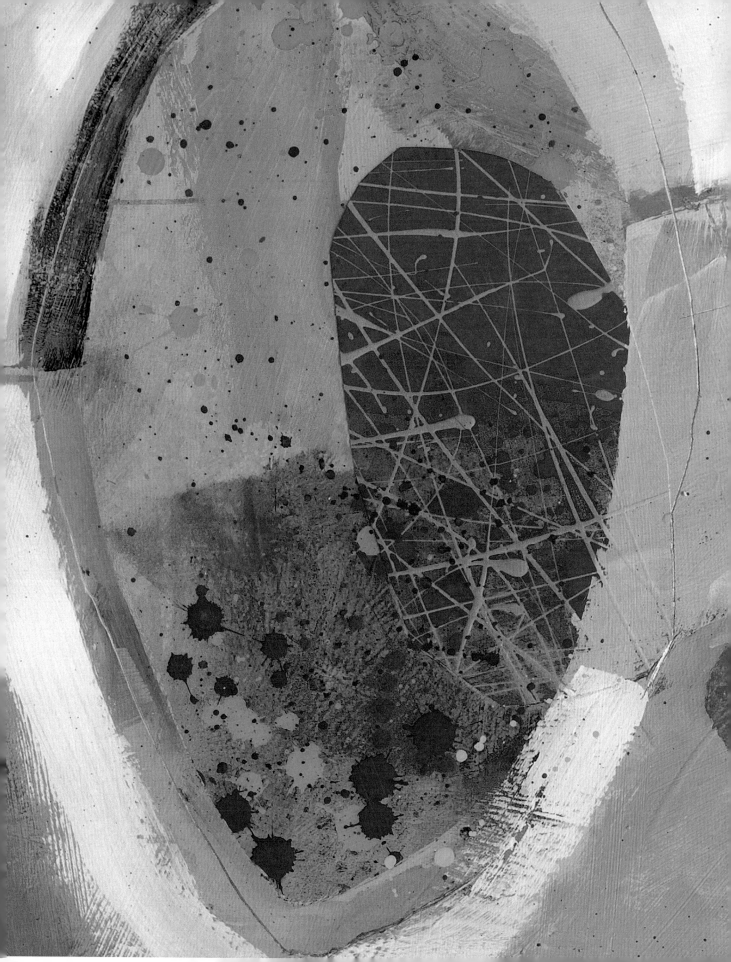

ABSTRACT PAINTING

The Elements of Visual Language

BY JANE DAVIES

TABLE OF CONTENTS

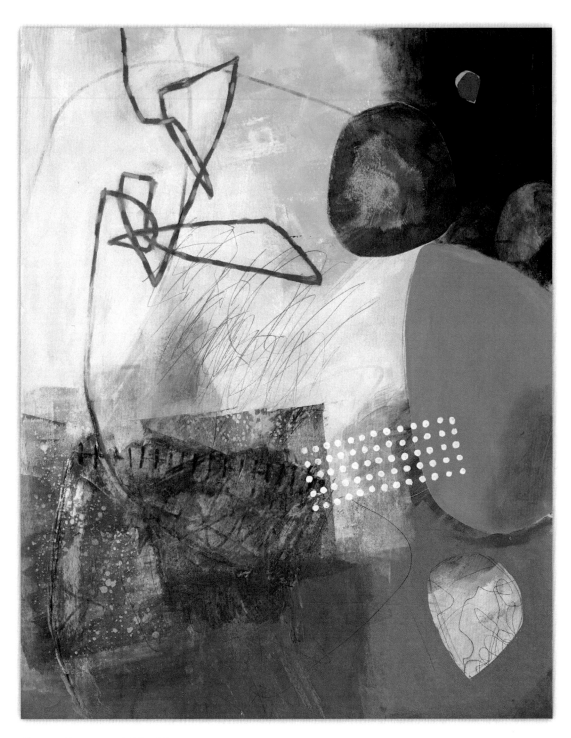

Natural Selection #1, 18 x 24 in.

PREFACE

In my teaching I discovered that when I asked students to tell me what they see in a piece of their own work, they most often responded by telling me how they made it. "I began with the gray background," for example, even if almost none of the gray is evident in the final piece. When pushed to leave out the technical process and just tell me what they see, the next step might be to say, "The graphite lines are veiled with white," for example. As a viewer, I may not even see the graphite lines, as they may be so obscured by the veiling. I certainly do not know that they are graphite. They could be colored pencil, charcoal, smudged marker, or something else. Another frequent response was something like an explanation for the piece: "this part 'works' *because of* that element," or "this line connects these two parts of the piece, *pulling it all together.*" Again, I get the impression that the student created a line with the *intention* of "pulling it all together," but is not actually observing the piece as it stands on its own. Speculation was another response I got frequently: "it *would have been better* had I left out the red square," for example.

In one of my online classes, I required the students to make observations, say something about what they see in their work. Even after harping on this point repeatedly, to the imagined eye-rolls of my virtual students, they were still very wedded to the technical and material descriptions and struggled to come up with purely observational statements. This book is an attempt to articulate a vocabulary for observing your own work, or anybody else's work, in terms of its abstract visual content. I believe that the ability to *see* your own work is key to developing as an artist.

WORKSHOP IN GREEN VALLEY, AZ

PHOTO: GEORGE BOURET

INTRODUCTION

The process of learning to make art is like that of learning to speak. You learn the language, the grammar, the idioms. But what you say with it is totally up to you. My role as a teacher is in helping you to become more visually articulate, not just technically adept. Learn to see clearly what you have made, not just how you made it. Notice how *this* color affects *that* one; see how *this* element reads as a blob, not an image; see how *this* line has a different character than *that* line, for example. Notice where your eye moves on the page; notice what catches your eye first. Then, as an artist, it is up to you what you say with this language. Only you can make the images that come from you.

Art-making is about creating images using various techniques, but it is so much more about seeing what you have made, and seeing your pieces as they develop. Many techniques are fairly accessible, some taking only a few tries to master, once you are familiar with your materials. Seeing, however, is a skill that you continue to cultivate over time. Your seeing skills and your personal vision will evolve and change as your art practice develops.

The purpose of this book is to examine and articulate a vocabulary of basic visual elements, so that we can become more literate in line, shape, color, pattern, and depth, for their beauty and expressive possibilities. Learning a vocabulary of visual language is not in opposition to working intuitively and spontaneously. We learn to speak spontaneously, and continue to do so even after we have learned about sentence structure and grammar. Learning about our language does not make us more analytical speakers; rather, it can make us more aware of language and allow us to use it to articulate meaning more precisely.

We will look at what I call the "mechanics of composition," which is not rules of composition, but how visual elements affect each other and how they affect our perception of an image. Finally, we'll discuss looking at our own work and that of others. Beyond describing the visual elements and how they relate to each other, you can observe your response to the work. What kind of emotion does the work evoke? You might also see references to objects or places in your abstract compositions. This kind of observation and reflection is important in developing as an artist.

Though the focus of this book is on visual content, I am including a short section about the materials that I use. This is not meant to be comprehensive information on painting materials—there is plenty of information available elsewhere—but just about those that I use most frequently.

Learn to see your own work beyond technique.

Learn mechanics of composition not rules.

11

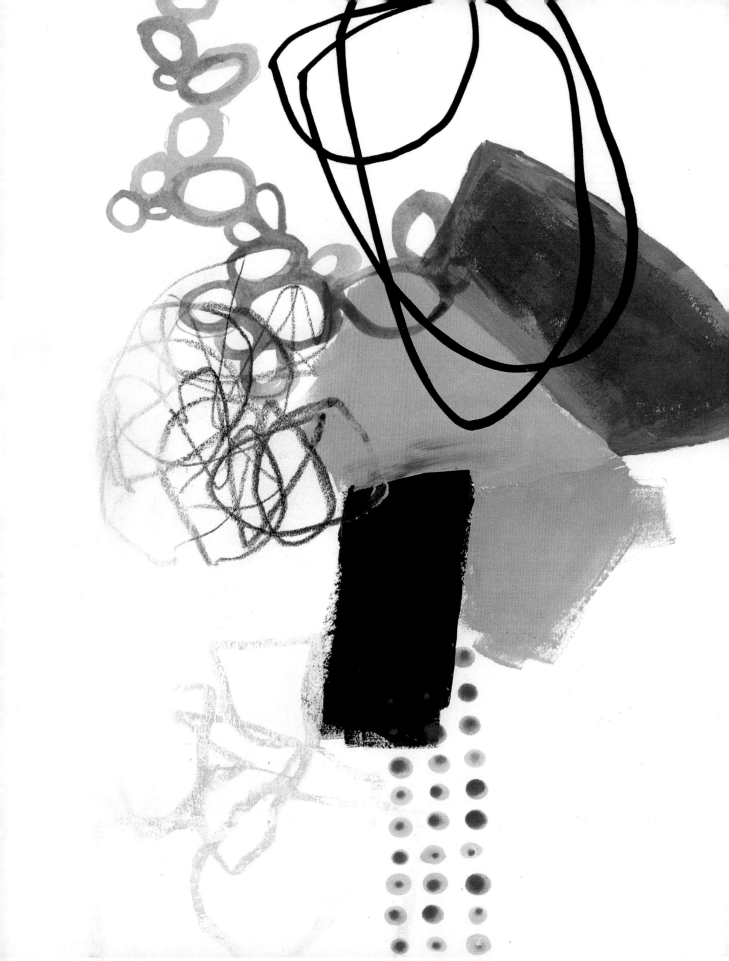

CHAPTER 1: ELEMENTS

The purpose of examining visual elements is not to come up with precise definitions and applications, but to make us more visually aware, both in the process of painting, and in looking at our finished work.

This is not an exhaustive list of all possible visual elements, just the list of those that I find most useful in abstract painting. Of course, these elements do not exist in isolation: a line can describe a shape; it can be a color, or even a pattern (a dotted line, for example). A line can be thick enough to be read as a shape so that it can be considered as either line or shape; a group of shapes can read as a pattern; a very small pattern can read as texture.

In painting practice, there is no need to strictly categorize every mark you make. Nor is there a necessity to

do so when viewing a painting. I find these categories useful, however, in observing my own work in process when considering possibilities of *What To Do Next*. When I want to move forward on a painting or a series, I observe what is there and what is not there in the painting, regarding these elements.

Bearing in mind these categories of elements overlap, that they are not necessarily distinct from each other, we'll go ahead with the imprecise business of examining them, one by one.

Line

We often think of line in terms of drawing, and drawing, in our common mythology, is the quintessential skill of making art. "I can't draw a straight line," *means* "I can't make art" or "I'm not creative." Also, we think of drawing as drawing *something*: drawing from life—a figure or a still life—or drawing a representation, however stylized, of an object. In this configuration, there is a standard of "getting it right." The more the drawing looks like the subject, the better.

I find that a lot of abstract artists are comfortable with color, atmosphere, texture, and shapes, and loads of expressive techniques, but are intimidated by line. I wonder if it is these associations with drawing that make it so. Creating a line directly with a pencil, pen, or marker, can feel very exposed. You have no fancy technique to hide behind. Nor, in the case of non-representational work, do you have a reference that guides your line. All you have is your tool, your hand, and your will.

In my workshops, students often resist the simple act of making a line. Perhaps it is because we've been overwhelmed with new techniques and art materials from the mixed media world, and we have come to expect that wow factor. Sometimes people resort to creating patterns and shapes using line, or they make line-ups of interesting squiggles or use an indirect technique (like stamping, for example) to make lines. Picking up a piece of graphite or a pen and drawing directly on the paper just does not seem like making art.

We are going to explore line for its own sake. You can think of it as scribbling, making marks, making a mess, doodling, playing, therapy, whatever. Just don't think of it as *drawing* if you are "not a line person."

You can make lines even if you think you can't draw.

LINE MAKING TOOLS

► Pencil

► Marker

► Graphite stick

► Crayon

► Felt-tip pen

► Ink drip

► Collage

► Paint

SUGGESTIONS
FOR VARYING LINES

► Apply your tools with varying amounts of pressure

► Use gestures that are different from each other.

► Vary the speed of your line-making

► Make lines with your eyes closed

► Do blind contour drawings*

 * Blind contour drawings are drawings you make while looking at the subject but not at the paper.

LINE STUDY 1

Make yourself a group of lines in as many ways as you can think of. Get out all of your line-making tools (see list of suggestions), and dedicate a stack of cheap drawing paper to this project, making a handful of lines on each sheet. The purpose of this study is simply to explore line making for its own sake. Make awkward, jerky lines; flowing, graceful lines; aggressive lines, tentative lines. Try holding a pencil or marker in your non-dominant hand, mouth, or between your toes and see how that affects the quality of lines you can make. Once you have put in some time on this, tack all these line samples up on a bulletin board, or tape them on the wall— get them in your visual field. Use them as reference as you make a group of "line studies" in which you combine and layer lines of contrasting character.

LINE STUDY 2

Create a series of studies in which you use line only, and each line is *as different as possible* from the others. Do not repeat one kind of line, but allow the lines to contrast, to have arguments or ignore each other. Consider it a dance in which each line is trying to trip up, or surprise, the others.

Create as much contrast as possible.

LINE STUDY 3

Using the previous two studies as reference or warm-up, make a series of pieces that use line and scribbling predominantly, but allow yourself to include bits of patterns, shapes, and areas of color. In the piece to the right, I did the scribbles in crayon and oil pastel, and then applied the paint, scraping it with a credit card over the scribbles. After that, I added some other finer lines with PITT® pen and paint marker.

15

Shape

We will focus on shapes as abstract elements, though shapes can make specific reference as well. Egg-shaped, heart-shaped, the shape of a dog, and so forth, are a few examples of shapes with specific reference. Abstract shapes are those that can be open to multiple interpretations. Whether they end up suggesting specific reference in a final piece or not is up to you and up to your viewer.

I do want to point out, however, that even the most generic shapes, such as circles, ovals, rectangles, etc., can suggest reference to something outside themselves. Circles, for example, can be symbols of wholeness, the universe, the Self, eternity, sun or the moon. A triangle can suggest a roof, an arrow, a pyramid, a tee-pee. A rectangle may suggest a building or a box, and so forth. Some shapes have this kind of universality; some have a narrower range of possible interpretations, and some are just "amorphous," but still can suggest "organic" (usually rounded, suggesting something living), or "geometric" (usually hard-edged, suggesting man-made or theoretical).

You can generate ideas for shapes by taking photographs or making sketches. Looking at a three-dimensional object from various angles can give you interesting variations on a shape. If you begin to sketch or photograph to capture shape ideas, you will see shapes everywhere! This is a great way to cultivate your visual awareness.

First, we'll look at a few simple techniques you can use to make shapes. Then we can play with combining shapes in compositional studies. Consider these all experimental, all part of the inquiry.

Shape Techniques

A FEW WAYS OF CREATING SHAPES

- ► Cut-paper collage shapes
- ► Line-drawn shapes
- ► Painted outline
- ► Painted solid
- ► Stenciled
- ► Stenciled/scribbled or stamped
- ► Negative shape painting
- ► Masking (use brayer or sponge)

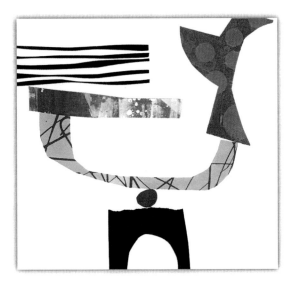

SHAPE STUDY, 8 × 8 IN.

The shapes in this piece are all cut-paper collage. Each one is cut from a different hand-painted paper.

Cut-paper collage is probably one of the first ways we learn the concept of an abstract shape. Shapes can be cut from a solid color, a pattern, texture, printed matter, translucent paper, opaque paper, etc. The material from which you cut the shape is as much a part of its visual content as the shape itself, its outline. The line-drawn shape and the painted shapes will likewise express the materials, colors, and manner in which they are executed. A stencil will define a shape's edges, and you can use it with many different application techniques and several materials. All of which is to say that even with a few suggestions of tools and techniques, you have the potential for enormous variety. For each technique mentioned above, there are infinite variations.

SHAPE STUDY 1:
THE SHAPE TECHNIQUE SAMPLER

Just like you did with line, give yourself some room to play with shapes. Try the techniques listed on the facing page, and make yourself a "shape sampler" for reference. You could keep it simple and use all circles or orbs for your sampler. Or vary the shapes if this will make the study more fun.

Make a shape sampler.

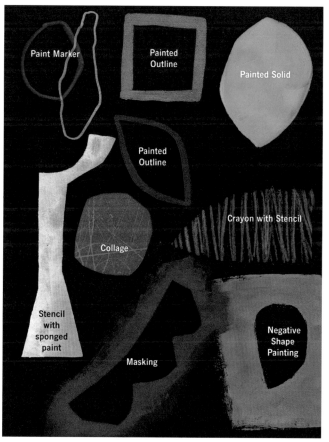

SHAPE SAMPLER: You can create infinite variations in each of the above shape samples by changing the color, the scale, the way you handle the material, and the materials themselves. Extend the Shape Study #1 by trying some of these variation on each technique.

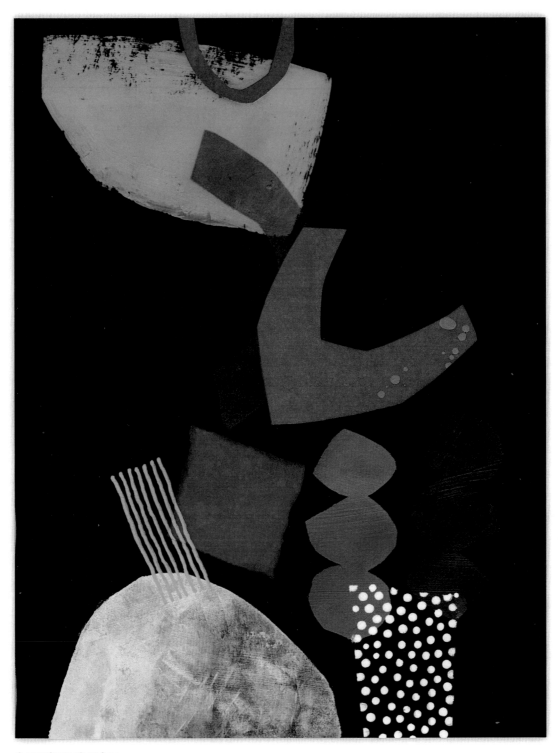

Shape Study, 9 x 12 in.

IMPORTANT CHARACTERISTICS OF SHAPES

In Shape Study 1 we are simply making a catalog of techniques. In the shape study on the facing page, we are looking at particular characteristics of the shapes themselves: this is the visual content, not the technique. Although you can vary the character of your shapes by using different techniques, ultimately you have to look at the shapes and see how they vary visually. For example, in the piece at left the pink shape and the neutral half-moon shape at the bottom of the page are both hard-edged shapes. Even though I have used two different techniques—collage and stenciling—the shapes are similar with respect to the character of their edges. The snowman shapes on the right contrast with the background to different degrees: high on the left, medium in center, and very low contrast on the one at the right, falling off the edge of the page.

Edges: hard edge, soft edge, ragged edge, etc. Shapes are to a great extent defined by their edges, but these can vary substantially. The blue shape at the top of the facing page has what I would call "ragged" edges. The red square (on an angle) has torn edges. The other shapes have more-or-less hard, well-defined edges.

Contrast: how much your shape contrasts with the background bears a great deal on how it "reads". Is it subtle contrast or strong contrast? Different in different places? In the image to the left, the transparent backward "C" shape has varying amounts of contrast, as it overlaps pink, blue, and black. It manages to read as a continuous shape because of the well-defined hard edge.

What constitutes the shape? Is it solid color? Pattern? There are two shapes in this piece that are created with pattern: the white dots at the bottom and the green stripes. To me, these read as both shape and pattern.

Opacity/Transparency: Is your shape opaque? Translucent? Ghostly? Barely there? The backward "C" shape, as we mentioned above, is very obviously transparent. You can clearly see the shapes behind it. The others are opaque, except for the half-moon at the bottom. That one is very opaque on the left, but becomes more translucent, like a veil, on the right.

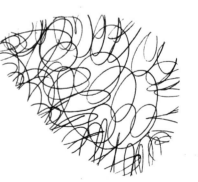

19

SHAPE STUDY 2: CUT PAPER COLLAGE

Cut a variety of shapes from collage papers: hand-painted solid colors and patterns, book pages, textured or printed papers, and the like. Include a wide variety of sizes: teeny tiny shapes, great big ones, and sizes in between. Try curved edges, straight edges, and torn edges. Play with these shapes in various arrangements against a solid ground (black or white usually work well for this). You can glue them down, make them "permanent" studies, or just fool around with them and take photos.

Negative Space: Pay attention to the negative spaces formed between the shapes. Allow the negative space to be just as important as the collage shapes, that is, give it equal attention. Vary the amount of negative space compared to the space occupied by collage shapes.

Scale: Vary the scale of your shapes within each composition. Most of us have a tendency to have all of our elements of similar size. Variety in scale is an effective way to create dynamic interest.

Color and Value: Pay attention to the color and, especially, value of your shapes. Try both variety in color and value, and sameness in color and/or sameness in value.

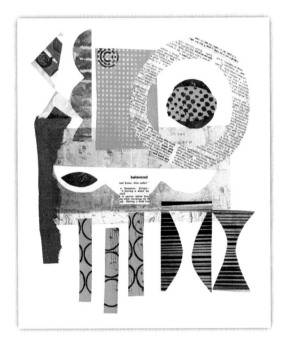

SHAPE STUDY, 9 x10 IN., BY LUCIE DUCLOS

WORKING HARBOR, 12 x12 IN., BY SUZANNE SIEGEL

Suzanne includes just a little bit of line in this cut-paper collage piece. Notice the contrast in the scale and attitude of the shapes. Also notice the range of contrast with the white ground: the white square that sits behind the other elements contrasts only slightly with the ground, while all the other shapes contrast to varying degrees.

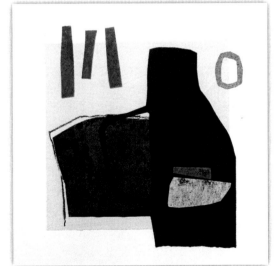

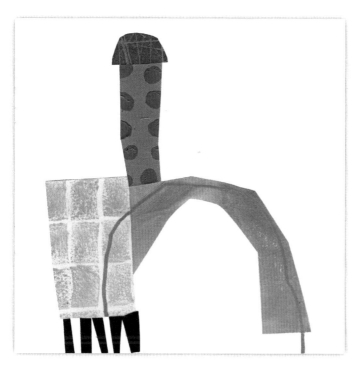

This is a simple cut paper collage composition with the addition of one gray line. Notice the difference in scale of the collage pieces.

Vary the scale, color, and value of your shapes.

SHAPE STUDY, LAYERED, 8 × 8 IN.

This piece began as cut paper collage on a black ground. I then painted over it creating new shapes, and added collage over that. Cut paper collage can be a starting point for focusing on shape. But you can continue to develop a piece by painting over, adding collage, and using other techniques.

Layer paint and collage until an image emerges.

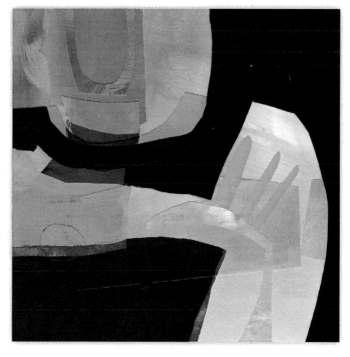

SHAPE STUDY 3

This exercise is surprisingly difficult. Most people stumble on either the issue of scale or the issue of technique. But when done correctly, the exercise brings a new awareness of several aesthetic issues. It also brings you in contact with your defaults or habits, so that you can *choose* to go with them or engage a new direction.

EACH PIECE HAS THE FOLLOWING:

▸ Include *exactly* five shapes that are similar in style (i.e. all rectangles or all orb shapes).

▸ Each shape is a significantly different size.

▸ Each shape is done in a different technique.

Use a different technique for each shape.

THE FOLLOWING ARE YOUR CHOICE:

▸ COLOR: you can make your shapes in contrasting colors, the same color, or similar colors.

▸ ARRANGEMENT: your shapes can be spread out over the page, all bunched together, clustered, overlapping, touching or not touching the edges of the page. In other words, the composition is up to you. A variation on this exercise is to have each shape different, rather than all in the same shape family.

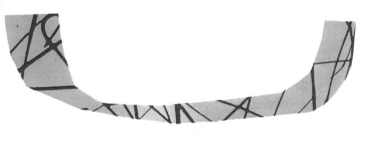

At right is an example of *Shape Study 3* described above. All the shapes are of a similar type: they are all orbs or ovals. Each is done in a different technique: the multi-colored shape at the bottom was made by painting black around it and then filling in the entire background in black. The large green outline shape is drawn with crayon and oil pastel. The gray egg is painted using a stencil; the yellow shape is painted directly, and the red doughnut is collage.

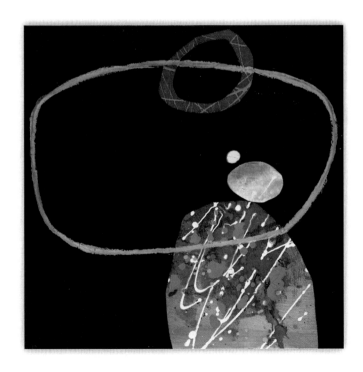

SHAPE STUDY 3 EXAMPLE, 12 × 12 IN.

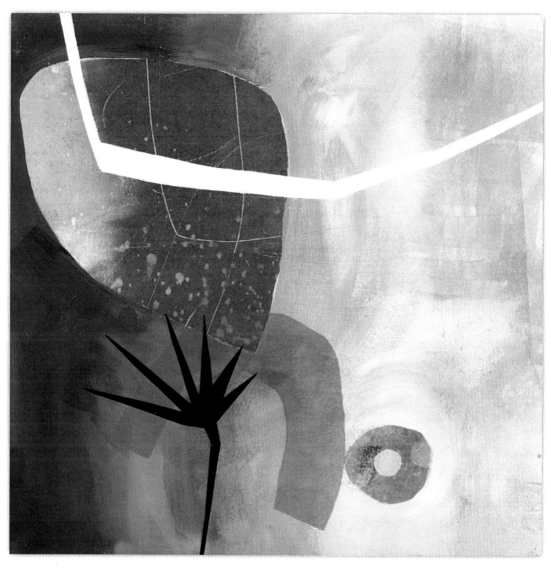

SHAPE STUDY #3 EXAMPLE, 10x10 IN.

Each of the shapes is different in kind as well as in size and technique. The shapes also vary in value, color, and opacity. The large pink shape and the small lifesaver are both mottled with oranges and pinks, while the other shapes read as solid color.

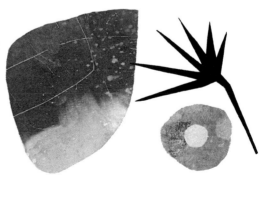

Mass

An area of color or veil without defined edges is what I call a "mass." I don't think we read these areas as "shape," which implies defined edges. Masses can be flat opaque color or basically one color with some variation. They can be used as elements in themselves, or as ground colors for your composition, or for painting over areas you've decided to edit out. A mass can be an area of translucent color, or "glazing," in which case it can function to unify the underlying elements. Another use of a mass is *veiling*: using opaque paint (I always start with white or a light neutral) in thin layers, creating the effect of fog or a "veil."

STUDY IN MASSES, 8 X 8 IN.

This study shows masses created in undiluted paint, watered down paint, and scribbling in oil pastel and crayon.

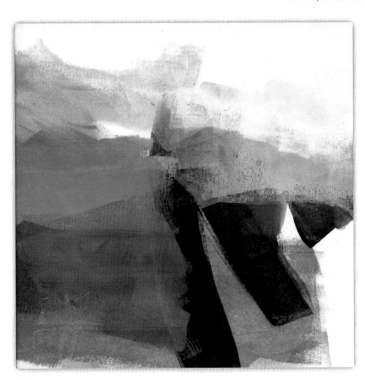

STUDY IN GLAZING AND VEILING, 10 X 10 IN.

In the study at left, Quinacridone Gold is used to *glaze* over the dark blue and light blue in the lower section of the piece. The upper portion is veiled with white, sending the dark blue and yellow ochre back into a varied thickness of fog.

Pattern

Any repeating element, whether it be a line, shape, dot, dash, splatter, scribble, or image, can form a pattern. It doesn't have to be repeated in a strict layout, as it would for fabric design (for industrial printing, that is), but it has to be repeated with just enough regularity to read as a cluster of the same element.

There are as many techniques for making pattern as there are for line or shape. You can paint a pattern directly using the brush mark as the motif. Or make a pattern from marks in graphite, crayon, or marker. Mask off a repeating element using masking tape or contact paper, and paint around it. Stencil a pattern, collage a pattern, drip or spatter a pattern, etc.

One technique that stands out as particularly appropriate for pattern is stamping, which is basically a print or transfer technique. Besides commercially made stamps, try carving your own or using small household items such as corks, bottle caps, corrugated card, erasers, etc. You can even use your fingers for stamping. Pick up the paint with the stamping tool, and transfer it to your substrate. I will not go into a whole stamping tutorial here because there is plenty of free material available on the internet.

Pattern can be seductive. It is relatively easy to make beautiful patterns from very basic tools. The simplest mark, repeated over and over, unfolds like magic, into a beautiful design, like weaving cloth. When using pattern in your art, remember that you are not doing fabric design. All-over, even, distribution of a repeated element is difficult to make into a compelling image. If you DO want to use an all-over pattern as the basis of your painting, consider subtle variety. We'll investigate this issue in Chapter 3.

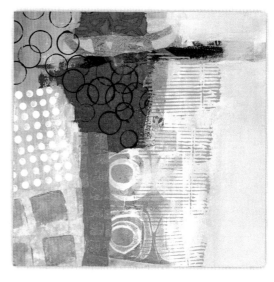

PATTERN STUDY #2, 10 x 10 IN.

In this piece you can see a variety of pattern scale, as well as well as various degrees of contrast. The bright orange-on-turquoise pattern in the upper left is very high contrast. The white and gray on gray on the left are low contrast.

Technique is secondary to the pattern you create.

For our purposes, the technique you choose for making patterns is not the focus. I want to bring your attention to three aspects of pattern that are important to an image: scale, density (or coverage), and degree of contrast. These three aspects have a strong effect on the visual impact of a piece.

SCALE

By 'scale' of a pattern, I mean the size of its elements relative to the painting. A circle, the size of a quarter, will be a significant element on a 4"x4" piece, but a mere dot on a canvas that is 48"x48". A pattern made up of repeating quarter-sized dots will read as a large-scale pattern on the small piece, and as a small-scale pattern on the large piece. This may be obvious, but it is important. If you are using more than one pattern in a piece, consider contrasting scale: use a teeny tiny pattern and a great big pattern, rather than two patterns of similar size.

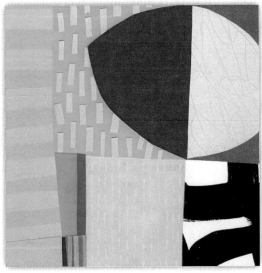

DENSITY

How crowded or spread out your pattern elements are is what I call "pattern density." You can have the same size of pattern element in a dense arrangement (crowded), or a sparse arrangement (spread out). Even though you use the same element, the two patterns will have very different impacts.

DEGREE OF CONTRAST

You have subtle contrast in a pattern if, for example, the pattern is pink and the ground is a slightly lighter pink. High contrast, such as black on white, or orange on blue, is definitely more dramatic, but you don't always want drama. You can use a whole range of degrees of contrast for different effects and in different contexts.

Most of the patterns in the piece on the left are low contrast, or tone-on-tone: the light turquoise and light green horizontal stripes on the left, the light green vertical dashes over turquoise, the yellow scratches in the yellow-green square at center bottom, for example. And they range from small scale to small-ish scale. The one pattern that stands out is the black and white at the bottom right corner. It looks like a large scale pattern squeezed into a small spot, and black and white is about as high a value contrast as you can get.

LEMON LOVE AGAIN, 8 x 8 in.
This is one in a series of pattern grids that I made in 2015 and 2016.

The two patterns in this image contrast greatly in scale. Both are black and white horizontal stripes, but they look and feel very different from one another. The large stripes are painted loosely, so that the edges are soft and a bit rough. The small ones are collaged, leaving crisp edges.

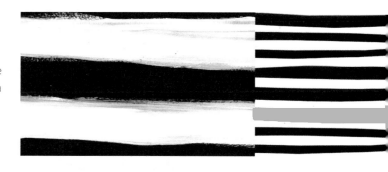

These two patterns are created from the same motif, or element, and on the same background. They read quite differently because of the spacing, or density. These patterns are made by stamping with a simple paint bottle cap.

This pattern of lifesavers shows a high contrast of color on the left: bright red against neutral chromatic gray. On the right the same pattern has very low contrast with the ground: magenta on bright red.

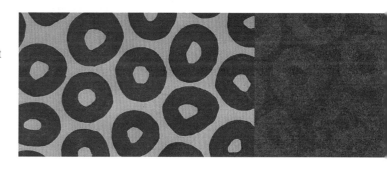

These three patterns are of medium contrast with the grounds. I find that unless you pay attention, all your patterns turn out to be either high contrast or medium contrast, which, when used together, can make a piece "too busy". Low-contrast pattern is, for me, the most useful: it can enliven an area of color without becoming the whole point of the piece.

USING PATTERN

I find that many people tend to define pattern by technique: the stamped pattern, the stencil pattern, and so forth. When seeking to create variety, it is tempting to simply vary the techniques or tools, but if they are all similar scale, similar density, and similar degrees of contrast, they won't read as substantially different in a painting. Creating patterns of very different sizes, different degrees of density, and different degrees of contrast will give you variety in your paintings. That is, in one painting, using patterns that vary in these partic- ular ways, will give you the most dynamic composition.

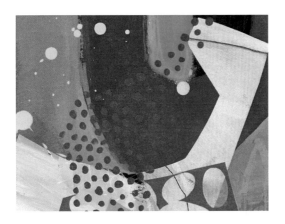

Use pattern to flow over several areas of a painting, creating continuity, as well as varying levels of contrast. In this detail you can see how the magenta dots overlap the areas beneath.

In this piece you can see how the pattern transitions from white on purple to purple on white.

Use pattern to create shapes, as Andrea Bellon did in this study. Notice how the shape appears to be transparent so that you can see the shapes beneath it.

SHAPE STUDY, 9 x 12 IN., BY ANDREA BELLON

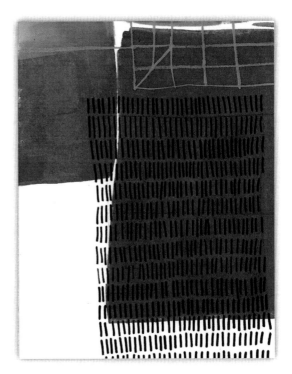

PATTERN STUDY 1

Assemble a stash of collage papers with patterns that vary in scale, density, and degree of contrast. Pages from discarded books and magazines can be a good place to start. Type makes great visual pattern and is abundantly available in various sizes. Decorative papers, scrapbook paper, and gift wrap are other good sources. Create your own collage paper using your favorite pattern techniques. I use 60# or 80# Cheap Drawing Paper for my collage papers, first painting a wide variety of colors, from dark to light, and neutral to bright, and then painting patterns of varying scale and density.

I find that for collage it is best if you have mostly low-contrast or tone-on-tone pattern. High contrast patterns are very eye-catching, so using a lot of them in one piece can create visual confusion.

Notice the range of color, contrast, density, and scale of the patterns in this collection.

Create grid collages using both patterns and solid colors. Focus on variety of scale of your patterns, and varying levels of contrast. The rest will follow. Feel free to use paint directly on the substrate as well as collage. I like to do this study on 8" x 8" printmaking paper and work on several at once.

Use tone-on-tone patterns as well as contrasting colors.

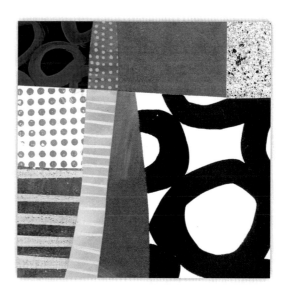

STRAIGHT UP, 8 X 8 IN.

Notice the contrast in scale between the black and white pattern and the green on blue pattern.

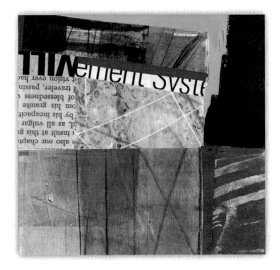

Typography, or found text, makes great collage material. In both of the pieces at left I've used found text in various fonts and sizes. Find a great variety of scale and density in magazines and the pages of discarded books. You can also create your own text material on your computer, varying the size, font, spacing, and so forth.

TEENY TINY ART #75, 4 x 4 IN.

I used several pieces of found text as well as some gelatin printed papers in this collage.

Use various styles of text as pattern.

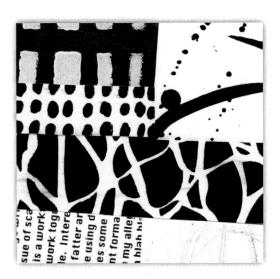

Limiting yourself to black and white patterns is a fun challenge. The density of the patterns becomes very important in how the piece is perceived. If you have very different patterns that are similar in density, they will look remarkably similar as visual elements. Vary the relative amounts of black and white in your patterns.

TEENY TINY ART #147, 4 x 4 IN.

Working with only black and white patterns is a particular challenge. This piece makes use of printed text as well as stenciled and ink-dripped papers.

PATTERN STUDY 2

Create a series of studies that feature pattern. Use at least three patterns of different scale in each piece. You can begin by establishing a large-scale pattern over a solid or variegated ground. Let the smaller scale patterns overlap the larger one and each other.

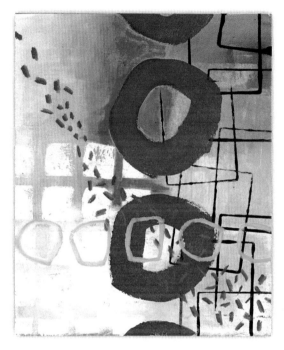

PATTERN PLAY, 8 x 10 IN.

This is a good example of pattern study 2, in that patterns feature prominently on a soft ground of neutral colors. The patterns contrast in scale and color, and they overlap each other, creating a kind of dance.

Combine huge, tiny, and medium scale patterns.

SPRING LINE-UP, 7 x 22 IN.

Notice how the pattern of green circles on the right overlaps the red area for high contrast, and a smaller area of green for low contrast. The green circles contrast in scale with the tiny green dots above, and also with the larger scale gray circles above and lighter green leaf shapes to the left.

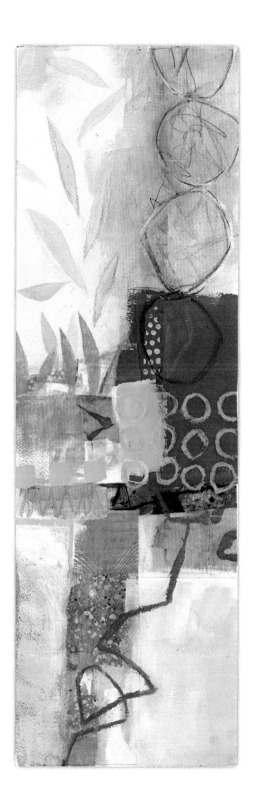

TEXTURE

We all love texture, as it is so tactile and evocative. It speaks of the material itself and brings us in touch with the physicality of a painting, its firm grounding in object-ness.

PHYSICAL TEXTURE

There are all sorts of texture mediums available to those working in acrylics: heavy gel, pumice gel, crackle paste, glass bead gel, and molding paste are just a few examples. You can create texture by adding sand, wood ash, or other textural material to your paint, or incorporate textured surfaces into your work. Corrugated card, sandpaper, embossed paper, fabric, and fibers can be used as collage. This is what I call

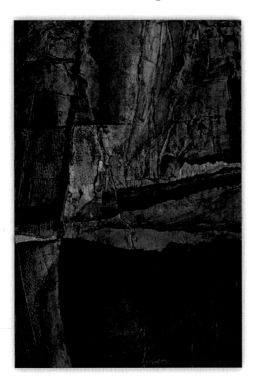

CLIFF HANGER #1, 10 x 15 IN.

This piece consists of heavy physical texture in the form of textured papers, fabric, sandpaper, and molding paste. I first established the textural composition, and then painted over it in metallics and translucent acrylics.

physical texture—texture that is physically part of the piece, and often very prominent. Physical texture can not be UN-done unless you remove the material. You can minimize the visual impact of physical texture by painting it with a matte, flat color, but it is still part of the piece.

TEENY TINY ART #116, 4 x 4 IN.

This piece features texture made by scoring the surface, then layering and scraping paint. The physical surface is actually pretty flat; the texture is visual.

VISUAL TEXTURE

Visual texture is relatively flat physically, but the visual impact is that of dimensional texture. Create visual texture by enhancing minimal physical texture (such as brush strokes) with a high contrast color. For example, you can rub a dark, staining, paint such as Van Dyke Brown or Carbon Black, into a brushed application of matte medium over a lighter tone, and it will pick up the texture of the brush strokes. Very minimal physical texture is a perfect surface for dry brush applications. You can create completely smooth visual texture, or implied texture, by applying paint with a textured surface, using it as a stamp or printing plate. Gel plate printing also produces characteristic texture.

In this detail of a study by Susan McCollum, you can see how dimensional the texture is. It is created by gluing dimensional materials, such as corrugated and small objects, to the substrate and then painting over them.

This is a texture created by scribbling into a wet application of matte medium with a knitting needle. When the matte medium is dry, enhance the texture by dry-brushing over it with a contrasting color, as I did here with turquoise. The physical texture of the matte medium is very shallow, so you could easily paint over it.

Scraping black paint into a surface that has even the slightest bit of texture enhances it immensely. In this sample, the texture is simply brush strokes of matte medium and some scoring with a knitting needle. The black is scraped over the surface using a credit card like a squeegee.

In this sample I used a gel printing plate to create textures. Roll the paint out onto the plate, press textures into it (in this case a plastic texture plate), and then pull the print. There are several coats of transparent green-gold paint here, all applied with the gel plate.

Choose textures according to the scale of your work.

I generally advocate for getting the most out of visual texture before using physical texture, precisely for the reason that you can edit it so easily, creating subtlety and nuance unavailable in highly physically textured surfaces. However, if physical texture is what you want to work with, go for it! Get the most out of it by using textures that vary in scale, in depth, and in character.

A NOTE ON SCALE: whether physical texture or visual texture, the actual depth and scale of it is in relation the scale of your piece. When using texture, be sure to look at it in terms of the whole piece. Texture that is very strong when viewed up close, may look quite flat when viewed from a short distance. Typically, you will view small pieces at close range, and larger pieces at some distance. The corrugated cardboard in Suzanne's piece below would read quite differently in a piece that was much larger. Her subtle sandpaper textures and printed visual textures would get completely lost. They have quite an impact, however, on this 12" x 12" format.

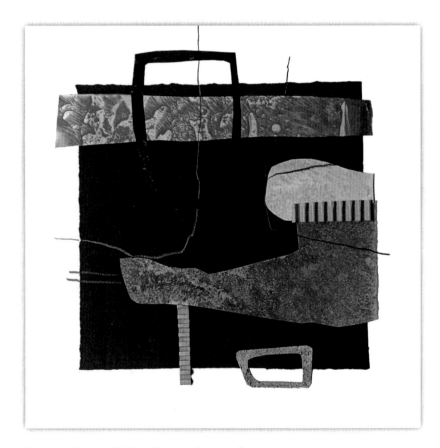

WORKING HARBOR XX, 12 x 12 in., BY SUZANNE SIEGEL

In this piece Suzanne Siegel uses a combination of physical texture and visual texture. Notice how the bits of physical texture—the corrugated cardboard—are quite small, and yet they have a big impact. Sparing use of pronounced physical texture can be just the detail you need to give your piece some punch.

WORKING HARBOR IV, 12 x 12 IN., BY SUZANNE SIEGEL

The physical texture in this piece—in the light gray shape—is subtle. Yet it forms a beautiful contrast to the flat white of the background and to the visual texture of the other shapes.

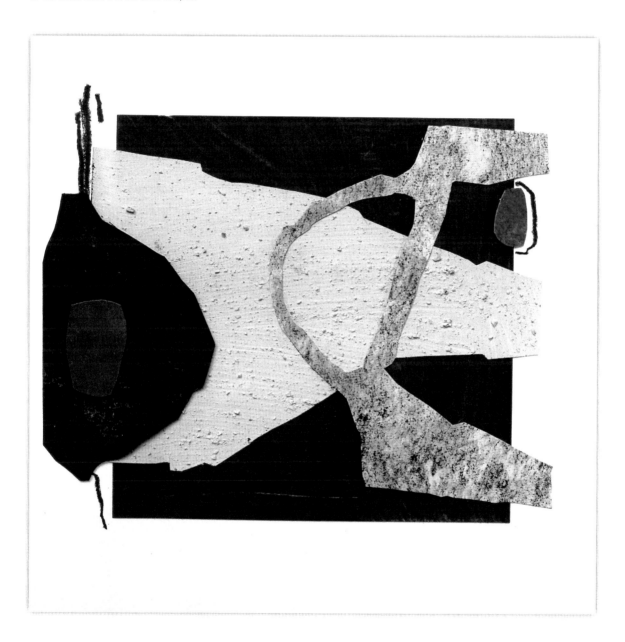

Depth

There is something compelling about looking at a flat picture plane, and perceiving the illusion of depth. We are so accustomed to seeing representational images this way—think perspective—that the convention seems natural. In a representational painting, the convention is that objects in the distance are to be depicted as smaller. If we see small mountains on the horizon behind a large tree, we don't perceive it as a tree that is larger than the mountains. We perceive it as the tree in the foreground and the mountains in the background; we perceive space or depth.

SHADING

You can use classic methods of shading to suggest volume, and thereby three-dimensional space. The cubists used this to great effect.

CONTRAST OF EDGES

Another way to depict depth is a contrast of edges. Sharp edges will tend to come forward, while soft fuzzy edges will tend to recede, creating the illusion of space.

CONTRAST OF SATURATION

Contrast in color saturation can also suggest depth, with brighter more saturated colors tending to come forward and muted colors receding.

In abstract painting, there is no such convention because there is no assigned reference to any of the elements. If one shape is smaller than another, you don't necessarily perceive depth because there is no point of reference. And yet sometimes a contrast in scale does suggest depth. It depends on the context and on other aspects of the painting. Let's take a look at a few techniques that can create a sense of depth. Of course, each painting is different, and these methods may work in one context and not in another.

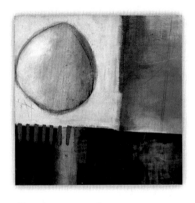

EDGE LOCATION #4

The orb in the upper left quadrant appears to have volume because it is shaded.

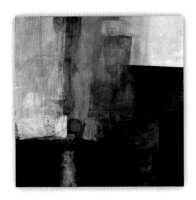

EDGE LOCATION #3

The hard edges and bright red and gold seem to come forward, as the softer edges and muted colors recede.

GLAZING AND VEILING

My favorite way of achieving a sense of depth is by actually layering the paint physically. Glazing, or painting a transparent color over an area, often suggests depth to some degree. Veiling, or painting over with a diluted opaque color such as white or gray, suggests a depth of fog or mist, with elements behind it in the distance.

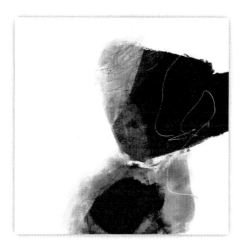

LAND LINE #2, 12 X 12 IN.

This piece makes prominent use of veiling, applying layers of diluted opaque white over the main elements. This creates a sense of depth, the shapes sitting *behind* the fog.

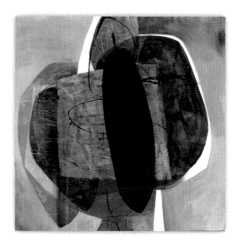

SHAPES #20, 10 X 10 IN.

Seeing some of the shapes through the translucency of others suggests a definite spatial arrangement. The turquoise orbs are sitting *behind* the central square and the black oblong shape.

OVERLAPPING ELEMENTS

Allowing an element such as a pattern or scribble to extend across two or more elements beneath, can create the sense that it is sitting *in front of* the elements it overlaps. The piece at right makes great use of patterns and scribbles overlapping the lines, shapes, and patterns on the ground layer.

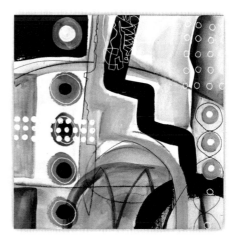

SCRIBBLE PAINTING #11, 10 X 10 IN.

This is one in a series of pieces I did to explore overlapping elements.

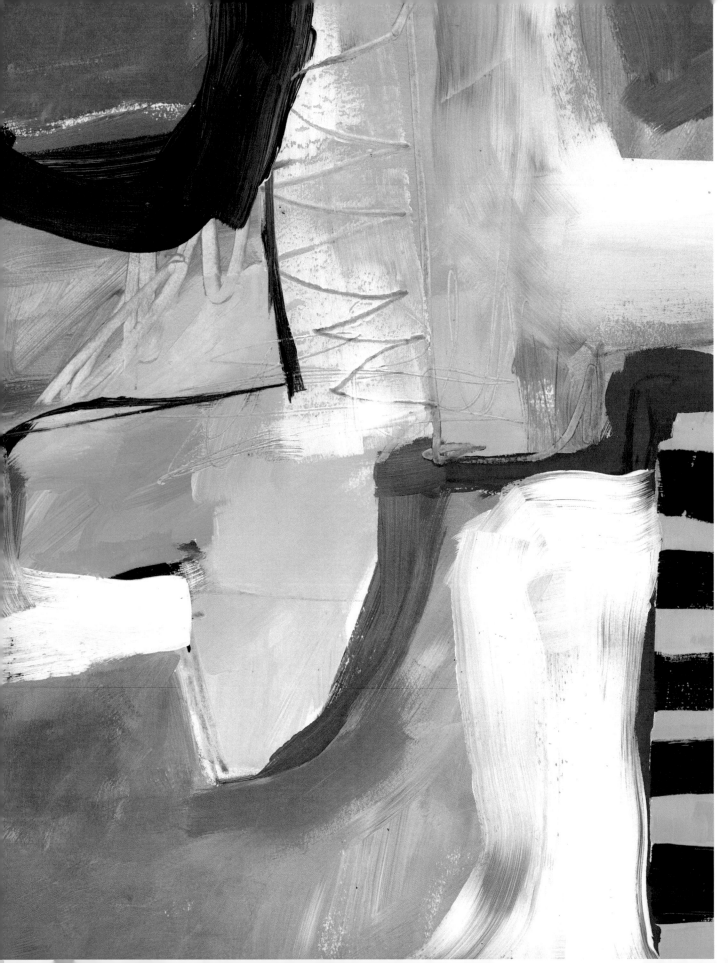

CHAPTER 2: COLOR

I consider color to be one of the main *elements* of painting, and I am giving it a separate chapter because it is pervasive throughout the previously discussed elements. A line, a shape, a pattern, for example, all have color—I include black, white, and all the neutral grays in between, in my use of the word "color," because I think that is how we speak of them in common parlance.

Hue

With so many excellent publications and workshops on color available, I will skim over the basics and get to the aspects of color that I find most useful in painting. Then I will suggest a few ways in which you can explore color beyond the color wheel, and develop your own personal palette. Let's just quickly review basic color vocabulary and some of the relationships among colors that are illustrated by the color wheel.

PRIMARY, SECONDARY, AND TERTIARY

Primary colors are red, blue, and yellow. Of course, there are lots of different reds, blues, and yellows, which you can explore, but for the purpose of color vocabulary, we will imagine "pure" primaries. That is, for example, a red that does not tend towards orangey-red, nor towards magenta, or blood-red, or pink. Imagine a pure red with no other attributes. Do the same with yellow and blue. These are the colors that cannot be mixed from other colors. They are like prime numbers or axioms. They form the foundation of all other hues.

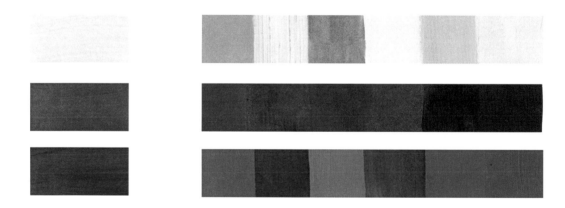

PRIMARY COLORS

The three swatches on the left represent what I consider to be pure primaries. These particular pigments are Hansa Yellow Medium, Cadmium Red Medium, and Cerulean Blue Chromium. There are certainly other yellows, reds, and blues that would appear to be as "pure" as these. What is more interesting to me is the sheer variety of each of the primaries. The above swatches of yellows, reds, and blues are just a sampling of what is available straight from the tube or jar.

COLOR

Secondary colors are those mixed from the primaries: green from blue and yellow; orange from red and yellow; purple from red and blue. The **tertiary colors** are those in between the primaries and the secondaries on the color wheel. There are six tertiary colors in a standard color wheel: red-violet and blue-violet, red-orange and yellow-orange, yellow-green and blue-green. And, of course, there are infinite gradations between these as well.

The three primary colors are equidistant on the color wheel, dividing it into thirds. The three secondary colors are also equidistant. Each one of the secondary colors lie right in the center between two primaries. Each of the six tertiary colors lies between the primary and secondary colors from which it is mixed. Complementary colors are directly opposite each other; analogous colors are adjacent to each other.

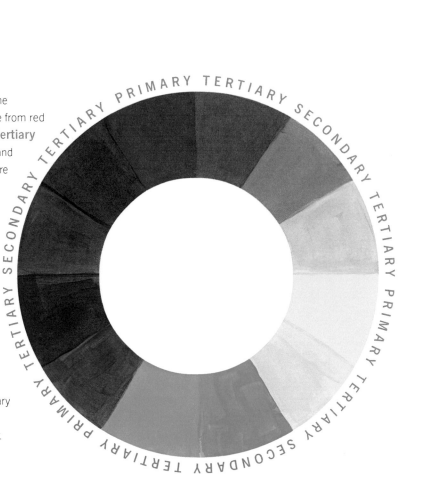

COLOR RELATIONSHIPS

Complementary colors, sometimes called "opposite" colors, are those directly across the color wheel: red and green; blue and orange; yellow and violet, for example. The important thing about complimentary pairs is that they create the greatest *contrast* of hue. This is important in composition.

Analogous colors are those next to each other on the color wheel. Red, red-orange, and orange are analogous. But what about red, orange, and yellow? Are they analogous? They are a little further apart on the color wheel. Whether you consider them analogous depends on the particulars. For example, if you have a magenta-like red in this threesome, the purple-ish quality could look more like a complement to the yellow. If you have a cool, greenish yellow, it may

contrast with the red (red and green being complementary) more than an analogous combination would. Think of analogous colors as those that easily go together, without clashing or getting into arguments.

GREEN VALLEY #4, 10 x 10 IN.

This is a study in the complementary colors orange and blue. I included a lot of variations in the orange: from light peach and salmon to deep burnt orange.

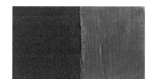

Red/Green

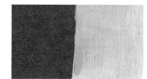

Magenta/Yellow-Green

Blue/Orange

Turquoise/Red-Orange

Purple/Yellow

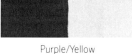

Blue-Violet/Yellow-Orange

PAIRS OF TERTIARY COMPLEMENTARIES

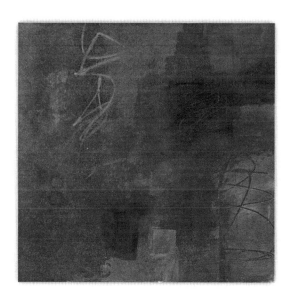

WARM COLORS, 12 x 12 IN.

This is a study in the analogous colors red and orange. It includes magentas and deep reds as well as primary red and red-orange. This very narrow range of hue gets its variety from changes in value and saturation.

ANALOGOUS COLORS:

yellow to red (top), purple to blue (middle), and blue to green (bottom). These include primary, secondary, and tertiary colors.

COLOR STUDY 1: COLOR WHEELS

Creating color wheels from different sets of primaries is a great way to discover the infinite range of hues that are possible, and to familiarize yourself with your paints. Invariably you come up with beautiful surprises.

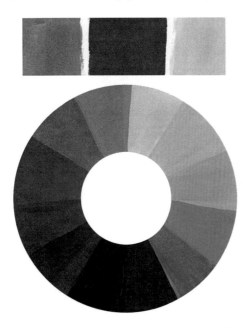

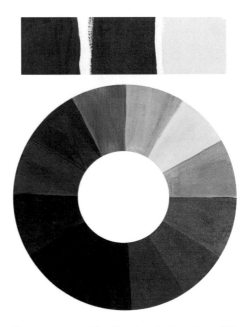

The primaries used for this color wheel are Naples Yellow, Quinacridone Magenta, and Manganese Blue Hue.

The primaries used for this color wheel are Hansa Yellow Medium, Napthol Red Light, and Cerulean Blue Chromium.

The challenge in making color wheels is in getting even steps between colors. Your secondary colors should be exactly halfway between the two primaries from which they are mixed, visually. Each tertiary color should be exactly halfway between the primary and secondary color from which it is mixed. I call these equal color "intervals." You can think of it in terms of distance: if red is at the one-mile marker, and the yellow is at the two mile marker, you want your orange to be as close to the one-and-a-half mile point as you can get it, visually. I stress "visually" because mixing colors is not a matter of using equal parts red and yellow to get orange. That never works. You have to gauge the intervals with your eyes; they have to look as equal as you can make them.

First, place your primary colors at equal intervals around the color wheel. Then mix your secondary colors (see tips on the following page), one at a time, and place them in between the primaries, leaving space for the tertiary colors. I find it helpful to test the mixtures on scrap paper before committing to the color wheel, as it sometimes takes a few tries to get them right. Another option is to paint your colors onto scrap paper and then cut out small pieces and arrange around the color wheel. This gives you more flexibility and some wiggle room for error. Finally, mix your tertiary colors. You will need to rinse brushes frequently or use a lot of brushes. Since color is the point of this exercise, keep them clean.

MIXING SECONDARY COLORS

▶ **Orange:** begin with yellow, and add red in small increments until you have orange.

▶ **Green:** begin with yellow, and add blue in small increments until you have green.

▶ **Purple:** begin with red, and add small increments of blue until you have purple.

COLOR STUDY 2: LINE BLENDS

The twelve colors in the color wheel are a convenient way to categorize hue. Explore the infinite variations between these twelve colors by creating what I refer to as "line blends," or gradations, from one color to another. In this case, we will look at line blends between analogous colors.

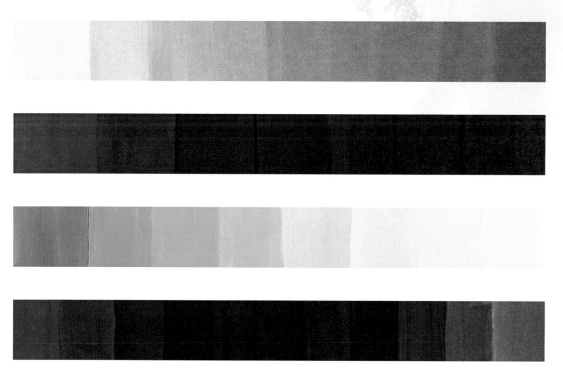

LINE BLENDS WITH ANALOGOUS COLORS:

yellow to orange, red to purple, green to yellow, and red to blue.

Value

"Value" refers to the lightness or darkness of the color. Paints come out of the tube (or bottle) in a particular value, but you can make a color lighter or darker by the addition of white or black, which, theoretically, changes the value but not the hue. These are called tints (adding white) and shades (adding black). If your paint is opaque, the surface on which you apply it will not affect its value or hue. When using translucent paint, its value (and hue) may well be affected by the color of the substrate on which you apply it. The value scales below are created with opaque paints plus white and black.

VALUE SCALES

starting with opaque colors, adding white for tints and black for shades.

COLOR STUDY 3: VALUE SCALES

To make a value scale, start with your color straight out of the tube or bottle, and paint a swatch. Add a little bit of white, just enough so that you can see a distinct value change. Make another swatch. Repeat until you are almost all the way to white. Now you have *tints* of your color. To create *shades*, do the same with black. It takes only the tiniest amount of black to make a big value change, and you want small, incremental changes. The key to value scales is getting the steps between the swatches as even as you can while making each value distinct from the others.

You can make value scales of translucent paints, like Manganese Blue Hue and Quinacridone Magenta, for example, by adding successive amounts of acrylic medium and applying the paint to a white ground. This creates a gradation of tints, but not shades.

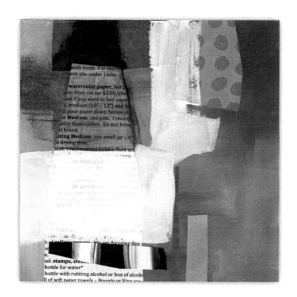

In this study at left, you can see how the value of a translucent paint, Manganese Blue Hue in this case, is affected by the colors beneath it. The translucent color straddles the book page (white with print), orange, quinacridone gold, and a deeper red-orange. The gray-scale version of the same image makes the value differences even more evident.

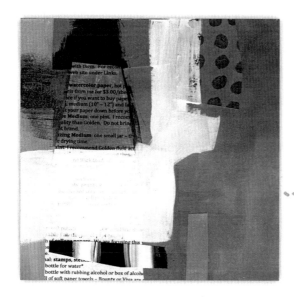

Another thing I notice in the gray-scale version is that the polka dots in the upper right, so eye-catching in the original version, almost disappear in this one. The values of the olive green and the gold of the background are almost identical, though they contrast in hue.

COLOR STUDY 4: VALUE CHART

It is often difficult to see the *value* of your colors, their lightness, and darkness relative to each other. Sometimes a brighter color appears lighter, even though it is the same value as a less bright color. Here is a way to make a chart that will help you. Eventually, you will be able to see value more clearly, so use this like training wheels.

Make color swatches of all of your most frequently used colors. Scan them or take a photo in daylight.

Then turn the photo to gray-scale in Photoshop or other image editing software (see facing page).

Create a gray scale using black and white only, with at least seven distinct values. It's best to do each value on a different piece of paper; that way you can edit out duplicates and get a scale with even steps. Also, photograph or scan your gray-scale and desaturate (digitally), so that you have similar grays as your colors. Then match the colors to the gray scale as shown in the chart below.

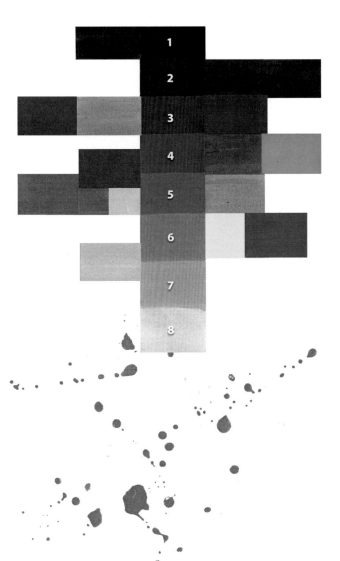

ROW 1: Jenkins Green

ROW 2: Anthriquinone Blue, Permanent Violet Dark

ROW 3: Quinacridone Magenta, Green Gold, and Pyrrole Red

ROW 4: Quinacridone Gold, Turquoise

Between ROW 4 and ROW 5: Medium Magenta

ROW 5: Cadmium Orange, Manganese Blue Hue, Yellow Green, Indian Yellow

ROW 6: Hansa Yellow Medium, and Cerulean Blue Chromium

Between ROW 6 and ROW 7: Naples Yellow.

High contrast in color is sometimes low contrast in value.

What surprised me the most in this value scale of colors is that the Hansa Yellow Medium and Cerulean Blue Chromium are very close in value. Compare the chart at left with the same image, desaturated, at right. Most of my frequently-used colors are in the mid-value range. I do a lot of modifying with white, creating tints so that in my paintings you will see a greater range of values.

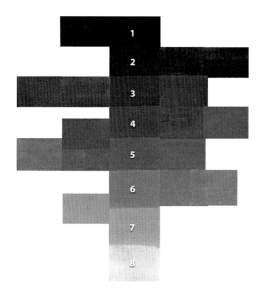

Gray-scale pictures are often surprising.

When working on paintings, I sometimes check the range of values by taking a photo on my iPad and then viewing it in the edit window in gray-scale. On the Photos app, "tonal" is the best setting for gray-scale. Often I discover that much of my painting is in the mid-value range with few areas of very light and very dark values. Some artists claim that if your painting looks good in gray-scale, or if the "value structure" looks good, then it works in full color. That may hold true for many paintings, but it ignores the enormous impact of hue and saturation. Like most "rules," it is best used as a lens through which to see your painting. But it is certainly not true that all paintings must have a broad range of values. Nor is it true that a good value structure necessarily makes a good painting.

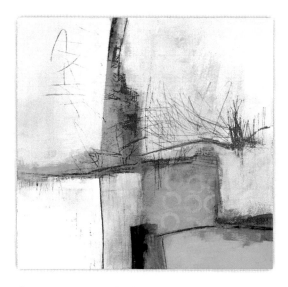 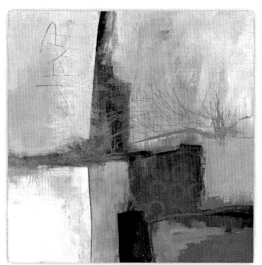

COASTAL FRAGMENT #9, 10 x 10 IN.
The range of values in this piece is made more obvious by viewing a gray-scale version.

Saturation

Most of us can get our heads, or our eyes, around the concepts of hue and value. We easily speak of colors regarding hue, and whether they are light or dark. "Saturation," which means the brightness or dullness of a color, can be a little more difficult to identify. Highly saturated colors and very muted colors are easy. But in between those extremes we don't necessarily describe

a color as mid-saturation. However, I find that if we are not paying attention, we tend to use colors that are all mid-saturation, that is, neither bright nor particularly muted. Including decisively bright and decisively muted colors to your palette extends your range in an important way.

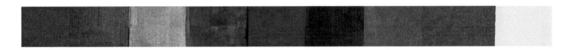

THESE BRIGHT COLORS ARE, from left, Medium Magenta, Quinacridone Gold, Green Gold, Manganese Blue Hue, Napthol Red Light, Quinacridone Magenta, Cadmium Orange, Vat Orange, and Hansa Yellow Light.

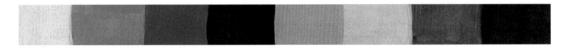

THESE MUTED COLORS are, from left, Titan Buff, Yellow Oxide, Chromium Oxide Green, Violet Oxide, Celadon, Naples Yellow, Raw Sienna, and Red Oxide.

COLOR STUDY 5: TONES

Bright colors need to be bright right out of the tube or bottle. You can always make bright colors dull, but you can't always make dull colors bright. In this study, we are making bright colors dull by adding neutral gray. Adding neutral gray to a color in successive amounts creates what we call *tones*. Do this exactly as you would in creating tints or shades, but the result is a gradual diminishing of saturation without altering hue.

BISMUTH YELLOW

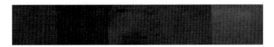

LIGHT TURQUOISE

IN THE ABOVE TWO GRADATIONS of tones, I mixed a neutral gray from white and black, that was the same value as the color I was testing. This gives me muted, or "toned

down" versions of Bismuth Yellow and Light Turquoise without altering the hue appreciably. You can also do the same kinds of gradations using lighter or darker neutral grays.

THE ABOVE TWO IMAGES are the tone gradations pictured above but in gray-scale. Though the tones may look darker in the color versions of the gradations, you can see from the gray-scale images that the values are very close.

COLOR STUDY 6: BLENDING COMPLEMENTARY COLORS

Another way to create muted colors and neutrals is by mixing complementary colors in various ratios, and then mix those with white. To create a gradation from one color to its complement, start with a pure color (Pyrrole Orange in the example below), and add successive amounts of its complement (in this case, Chromium Blue Oxide), making swatches as you go. Aim for even steps between the swatches such that each resulting color is distinct.

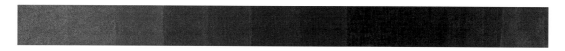

THE ABOVE GRADATION BEGINS with Pyrrole Orange, straight from the tube. I added successive amounts of Chromium Blue Oxide to create muted oranges, browns, deep blue-browns, and deep muted blues.

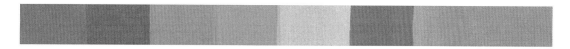

I ADDED WHITE to the various mixtures of orange and blue, in no particular order. The result is an interesting range of grays, taupes, and muted lavenders.

With your various mixtures out on the palette, begin adding white to them in an unsystematic way. Explore the range of neutral colors you can achieve using two complementary colors and white.

Try this exercise with as many pairs of complementary colors as you have in your paint stash. You will find that it does make a difference which colors you use and which particular pigments. Notice how different the neutrals blended from purple and yellow, below, are from those blended from orange and blue. Some pairs of complements almost cancel each other out in terms of hue, and create very neutral, almost colorless, grays. Others, such as the examples on this page, produce much more chromatic neutrals.

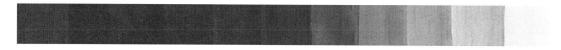

THIS GRADATION BEGINS with Light Violet, which is an opaque, mid-value purple. I added successive amounts of Hansa Yellow Medium to it, creating muted purples, warm browns, fawn colors, and mustard yellows.

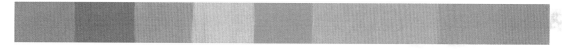

MIXING WHITE with the various mixtures of purple and yellow resulted in this palette of muted mauves, buffs, and dusty lavender.

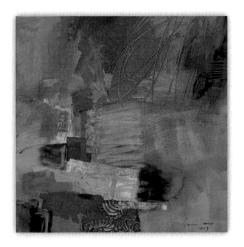

BLUE ORANGE #1, 10 x 10 IN.

This piece not only makes use of the complementary colors blue and orange, it is also composed mostly of bright colors.

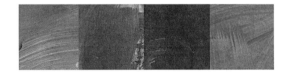

GREEN STRIPES #1, 18 x 18 IN.

Muted colors predominate this piece: olive greens, subdued mustard yellow (think Grey Poupon), and somewhat muted turquoise cover most of the area.

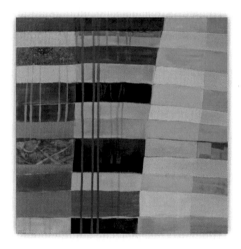

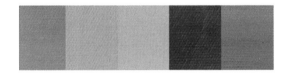

NEUTRAL #11, 10 x 10 IN.

This piece is made entirely of neutral colors: various versions of gray, a little accent of black, and a veiled gold.

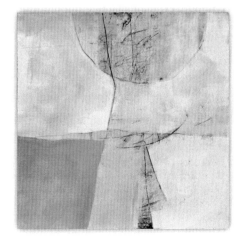

Transparency

One other important aspect of color is translucency and opacity. This is more about actual pigments and paints than about color per se, but it is in the context of actual paint that we use color. Below is a simple chart showing paint swatches painted over two black lines. You get to know which of your paints are translucent and which are opaque by using them, but it is easy to make a quick chart like this.

You can make opaque paints more translucent with the addition of clear acrylic mediums such as glazing medium or matte medium, but they will retain a chalky characteristic. I refer to this look as "veiled," as if there is a veil of tulle or fog over your piece. This is very useful in creating depth.

Truly translucent paints retain their clarity, no matter how many coats you use (within reason). You can make them opaque with the addition of white, but of course, that also makes them lighter.

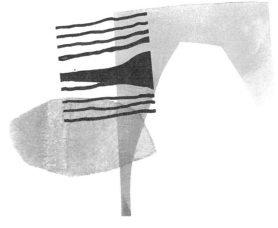

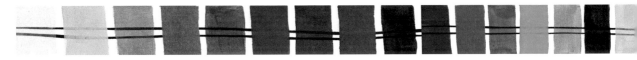

TRANSLUCENCY CHART

This chart shows paints applied over two black lines. You can tell at a glance how opaque or translucent they are.

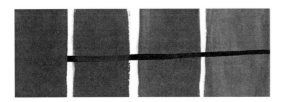

MEDIUM MAGENTA

is made more translucent by adding glazing medium. It retains a little bit of a chalky characteristic even when diluted. This is because it contains opacifiers.

MANGANESE BLUE HUE

is a translucent paint, but is made opaque, and lighter, with the addition of white.

Using Color

HONOR YOUR COMFORTABLE COLORS

As you gain experience in painting you inevitably develop your own color palettes and go-to color combinations. Occasionally I hear from a student that she did not bring her "favorite" colors to a workshop because she wanted to challenge herself to use new colors. Or a student says she used particular colors because they are not ones she is comfortable with. Though it is good to challenge your "comfortable colors" occasionally, I suggest you also honor your own sensibility and taste. If that quinacridone gold with black is still calling you, then don't shy away from it. Use it, and use it with confidence! Often you are challenged on other fronts—you might be working at a scale that feels uncomfortable, or trying new imagery. I suggest you stick with your comfortable colors in the context of other challenges. Then occasionally dip into a new color. Every time I order paint I include a color I haven't used before. Sometimes I don't open the tube for months, but as long as it is in my stash, it is somewhere in my mind to use it.

Even if you are super proficient at mixing colors, it can be useful to buy as many of your frequently used colors as possible so that you have them handy. Every time I want to use a light, opaque turquoise, for example, I could mix it from pthalo green and titanium white, but it is better for my workflow if I simply have this color available straight out of the tube.

When I want to challenge my color sensibility, I do so very deliberately, rather than trying to sneak in new colors in some other project. One little exercise (if it can be called that) I do is to come up with color combinations—only two or three colors—that are just as ugly or jarring as I can make them. Going for *ugly* with gusto and confidence will generally get you further than pussyfooting around slightly not-quite-pretty. Sometimes I find the most jarring combinations work beautifully in small doses.

CREATE VARIATIONS ON COLORS

You can create variations on a color by the addition of white or gray, or other colors. A couple of my favorite colors to play with are turquoise, and pink. To turquoise I add varying amounts of Pthalo Green, white, and a few different yellows to create a range of pale green to rich turquoise. To create interesting pinks, I start with a magenta and add white, Naphthol Red Light, and Pyrrole Orange. The results range from light magenta to bubblegum pink to coral and lipstick. Try this with a few of your frequently used colors.

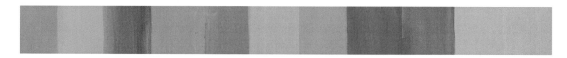

Turquoise, Pthalo Green, white, and a few yellows.

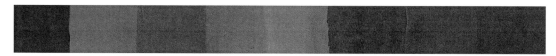

Magenta, Pyrrole Orange, Naphthol Red Light, and white.

ENRICH AREAS OF COLOR

If you are working with a large area of color, you can give it depth and nuance by adding colors that are close on the color wheel, or more versions of the same color. In the piece pictured at right, I enhanced the deep red area by using Quinacridone Burnt Orange, Alizarin Crimson, and Pyrrole Red. The orange area is enhanced by several different orange paints, mixed with white and with yellow, as well as a brush stroke of pure yellow. The piece reads as two main areas of color, not as a lot of different colors.

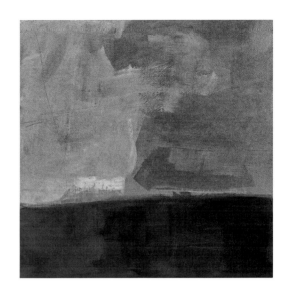

MONOLITH IN RED, 19 X 25 IN., ACRYLIC AND DRAWING ON PAPER.

In this piece, the red and blue areas are very prominent. I enhanced a basic primary red with red-oranges and deeper reds, as well as transparent reds such as Quinacridone Burnt Orange, Alizarin Crimson, and Quinacridone Crimson. The blue is layered with Quinacridone Gold and bits of turquoise to create a distressed, textured surface. It still reads as one large area of blue.

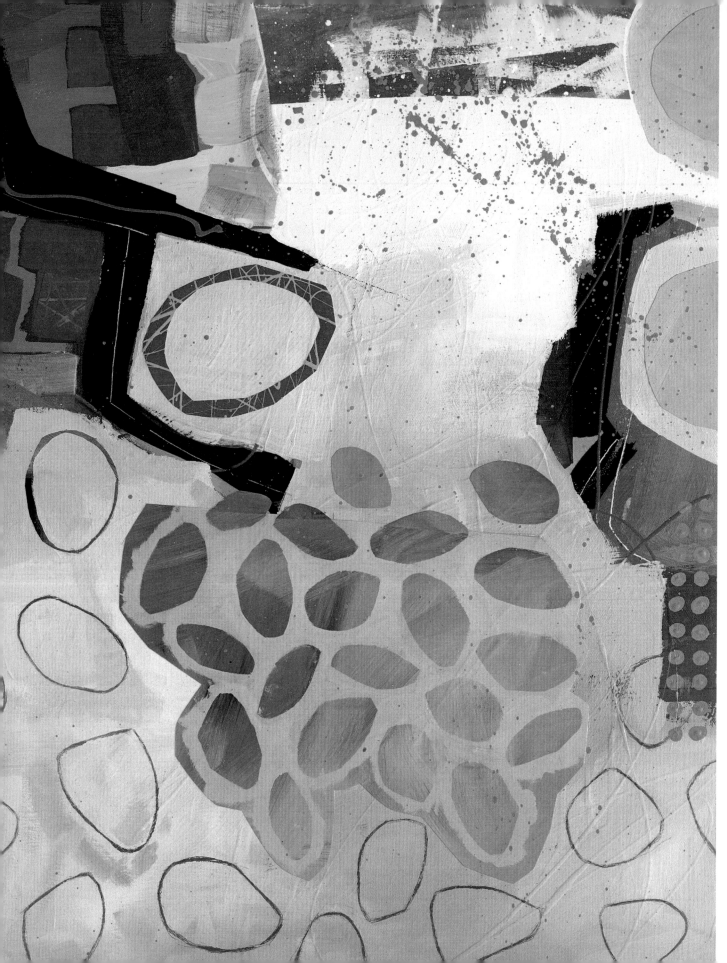

What Is Composition?

Composition in painting means the arrangement of elements and their relationships to one another within the frame of the piece. It is not about the interpretation of a painting, or its emotional content, or its references. It is simply the totality of its abstract visual content. This holds true whether the work is representational or abstract. Composition can often play a larger role in abstract painting, however, because, to some extent, the composition IS the subject matter. There is no representation of an object to evoke meaning. But even a representational painting will be more compelling if its abstract composition, the arrangement of its elements, is more interesting, or somehow supports the subject matter.

Usually my students understand the individual nature of color preferences, mark-making styles, choice of materials, techniques, and imagery, but when it comes to composition many of them want rules and formulas. The fact that there is not a formula for creating good composition is a good thing. It means you can explore composition and use it as a means of personal expression. You are free to cultivate your own compositional style or voice, the same way you develop your color preferences and mark-making styles.

Composition is the arrangement of abstract elements.

Composition is as individual as your color palette.

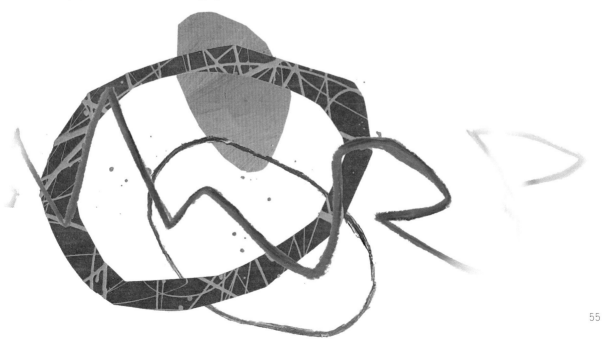

Looking at a large sampling of good art and trying to infer some general rules for good composition seems like a worthwhile endeavor. It might shed some light on important or useful art concepts. But it does not necessarily lead to rules or formulas for how to *make* good art. By its very nature art defies this kind of analysis. For every "rule" or generalization you come up with, there will be just as many "good" pieces of art to which it does not apply. Composition is sometimes taught in a way that students interpret as a set of rules. For example, I have come across the belief that the focal point should be in one of four spots: those that are a third of the way from two perpendicular edges. Or that elements and/or colors should be repeated in diagonally opposite quadrants to achieve balance. These rules provide reference points, but I think they should be treated more like hypotheses, to be questioned in the context of individual pieces of art.

Art concepts do not lead to rules or formulas.

HERE ARE SOME HELPFUL WAYS TO LOOK AT COMPOSITION.

There are some hand-holds in understanding composition, but they are like training wheels. They are not rules, and they are not guidelines for *good* composition, but more like lenses through which to view your work. This can help you make decisions in moving forward. I encourage you to look at your work, both finished and in process, through these various lenses, without judgment or criticism. If, for example, you notice that all of your elements in a painting are similar in size, don't automatically conclude that you have to change that. Noticing sameness in a particular aspect of your painting shows you where you *might* go, not where you *have to* go. If you observe that you have a color hanging out alone, not repeating anywhere, you can decide whether repeating it will add to the painting or if it will dilute the power of that one swatch of color. *Neutral observation* helps you to consider various possibilities.

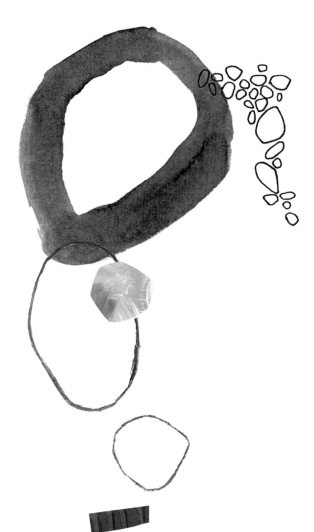

Contrast

I find contrast to be the most useful overarching principle in composition. You can look at many aspects of a painting through the lens of how much or how little contrast you have, and that can suggest options in moving forward. I do not mean that you have to have lots of high contrast to make a good composition, but that if you pay attention to the *degree* of contrast in a number of aspects, you can greatly increase your understanding of composition.

I think we often put too much emphasis on "unity," or having an image "hang together." Often you do want your piece to look *unified* rather than as a random jumble of elements. But I have found that it is more common to err on the side of too much unity at the expense of taking risks and finding your edge. Often my students seem to be a little afraid of contrast, of difference, and tend towards sameness all over and symmetry. Once they embrace the concept of contrast and difference, they are better able to navigate the

process and create more interesting and dynamic paintings. How much or how little contrast you inject into your painting, and in what aspects of it, is up to you. How much sameness, and where, and how much difference, depends on what feels right to you as the artist, for any particular painting. One person's "boring" can be another person's "meditative," for example. One person's "exciting and compelling" can be "an accidental jumble" to another. Very low contrast in one aspect, and high contrast in another might be appropriate for one painting, while a different painting may call for subtlety all over.

Contrast is a useful principle, while unity is our default.

Let's look at the principle of contrast in several specific ways.

SCALE

Scale refers to the size of elements in your painting relative to each other and relative to the size of the canvas. If your elements are all roughly the same size, your piece can look static or boring. Creating contrast in the scale of your elements is one way of making your composition more interesting or dynamic. If it is important to your piece that the elements be similar in scale, then consider contrast in other areas. But if you choose to create contrast of scale, do it like you mean it. Explore the range of contrast from subtle to overwhelming. In general, you may find that big contrasts in scale make for more dynamic images, but you really have to evaluate it on a painting-by-painting basis. Some paintings may rely on the sameness of scale, with contrasts in other aspects.

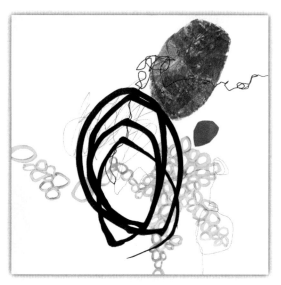

ELEMENTS #11, 10 x10 IN.

The scale of the big black circular scribble contrasts strongly against the fine lines above and behind it. The tiny purple shape at the right also contrasts in scale with the much larger shape above it, as well as with the heavy black scribble.

We notice difference more than sameness.

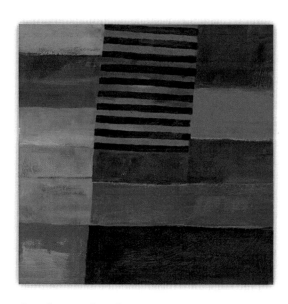

BLUE STRIPES, 12 x 12 IN.

To me, what makes this piece interesting is the contrasting scale of the stripes in the upper center.

In this altered image of the piece at left, the stripes are all similar in width. What I notice more in this version is the teeny bit of orange (again a contrast) peeking through on the left. Our eyes are drawn to contrast, wherever it may be found.

Green Red #1, 10 x 10 in.

The red here, used sparingly, contrasts highly with the various greens, since they are complementary colors.

COLOR

The highest contrast of *hue* you can achieve is from pairs of complementary colors, those that are opposite each other on the color wheel: Red/green, purple/yellow, and orange/blue. Analogous colors, those close together on the color wheel, are lower in contrast.

Orange Blue in Green Valley, 10 x 10 in.

Most of this piece consists of the analogous colors orange and red, with variations in saturation and value. It is the teeny bit of blue peeking through that catches our eye.

COLOR SATURATION

Another way in which colors can contrast is in terms of *saturation*. Contrast bright colors with muted colors or neutrals, such as grays and off-whites.

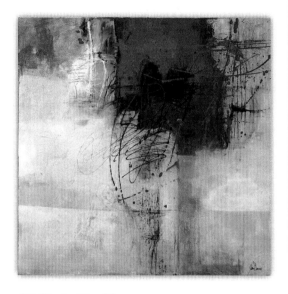

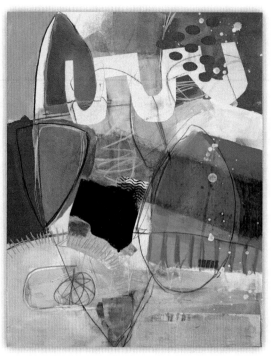

CHAOS THEORY #2, 19 x 25 IN.

In Chaos Theory #2, brighter colors take up most of the square footage of the piece, but they are set off by the neutrals in the bottom portion and upper left corner.

RED SPLASH, 36 x 36 IN.

In Red Splash, the bright colors draw your eye the most, but they actually take up much less space than the neutral grays, whites, and muted colors.

Consider contrasts in saturation and value as well as hue.

VALUE

Look for contrast in *value* of your colors as well. In the piece at right there are very dark reds on the left, some mid-value reds and oranges, and then a range of white and light colors down the center.

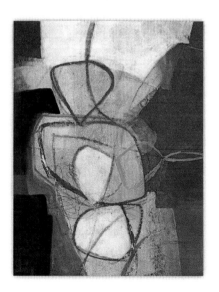

41/100, 9 x 12 IN.

DEPTH AND TRANSPARENCY

It is easy to get seduced by the beauty and luminosity of translucent paints. You can layer them to create rich color, texture, and depth, or use them as glazes to unify areas of your painting, in which you can see the elements underneath, as if through a colored glass. This transparency and depth can be very luscious and attractive, so why not make paintings that are All Gorgeous All Over? It could work, but it doesn't always, and in this respect, like all the others, you have to evaluate your paintings on a case-by-case basis.

All of the gorgeousness and luminosity may fall flat if there is no foil against which it can contrast. Emphasize the beauty of translucency by contrasting it with areas of opaque, flat color.

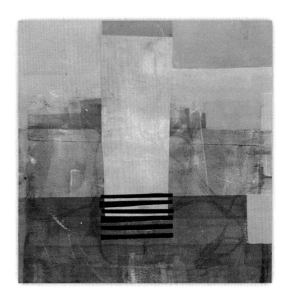

GRID-PRINT #11, 8 X 8 IN.
GELATIN PRINT WITH COLLAGE

This piece features the luminous transparency you can get by using translucent colors in gel plate printing. The solid, opaque, gray elements and the black lines make a strong contrast.

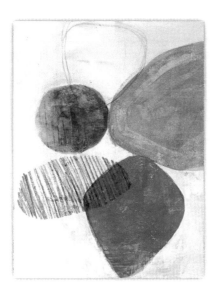

56/100, 9 X 12 IN.

Notice how three of the orb shapes just barely touch each other while the left-most one overlaps the blue shape. The largest shape goes over the edge of the page, while the blue shape just touches the bottom edge. Variety in these relationships is something you can explore.

DISTANCES BETWEEN ELEMENTS AND DISTANCES TO THE EDGE OF THE PAGE

You can vary the distances between elements and vary their relationship to the edge of the page to make a painting a little more dynamic. Often if we are not paying attention we end up with elements that are all the same in this respect: they all float the same distance from the edge of the page or are in very similar relationships to each other. Even in a painting with very little contrast of color, value, or scale, this one variable can make a big difference.

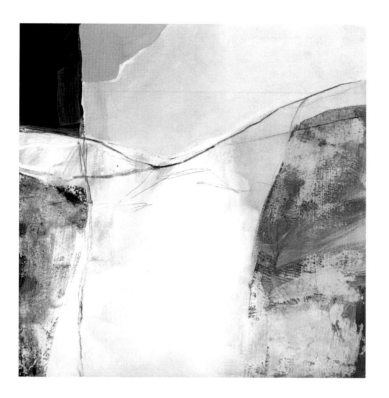

TEXTURE

Flat, opaque color, such as the light turquoise in the study at left, is useful to create contrast with texture. You can also use subtle texture to contrast with more dramatic texture. Texture of similar scale and drama, no matter how gorgeous and yummy, can be visually confusing if used all over the piece.

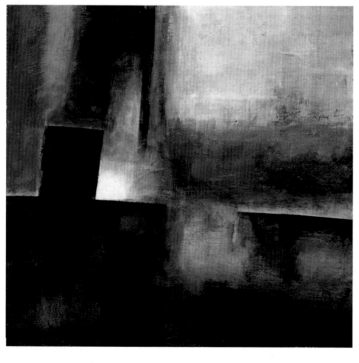

EDGES

Contrast hard edges with soft edges, torn edges with straight edges. The piece at left is a study in contrast of hard and soft edges. Hard edges can be high-contrast in color or value, such as the main horizontal edge just below center in this piece. They can be very subtle, as the vertical edge just below the red square.

Principles and Devices of Abstract Composition

BALANCE

The term "balance" is often used in descriptions of compositions, but it is used in so many different ways that I don't find it particularly useful. "Balance" does not necessarily mean symmetrical or asymmetrical; it does not mean equal visual weight on both sides of a piece, like two sides of a scale. It usually means "good," but it is often used for lack of more specific observation. "The piece is balanced" sometimes means no more than "I like it," or it has a sense of unity or 'rightness.'

Sometimes the word "balance" seems to be confused with symmetry. In my workshops, I find that students often automatically repeat elements in diagonally opposing quadrants of a piece: if there is a red square in the upper left, there must also be a red square in the lower right. The explanation is invariably about balance,

as if the piece would topple over if it didn't have the repeated element to anchor it down. "Repetition creates balance" seems to be taken as a given, and as a result, much of the work becomes predictable or "matchy-matchy." We'll discuss repetition later. Next I want to stress the overuse of the term "balance" and suggest thinking about it in a broader way.

Consider combining *unlike* elements. Like feathers and lead, you might "balance" a very dense, visually heavy, area with an expanse of open space. The piece would not be symmetrical, but it may feel 'balanced.' Contrast can create a sense of balance, perhaps in a more interesting way than repetition. But, again, you don't need to use the term "balance" at all: you could simply describe such a piece in terms of contrasts.

Consider "balancing" unlike elements, like feathers and lead.

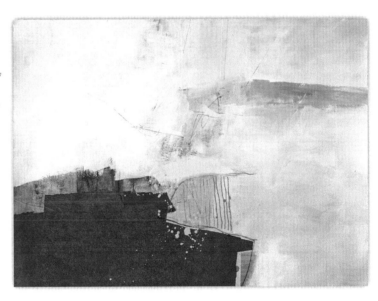

IT COULD BE ANYWHERE, 19 x 26 IN.

This piece combines the visually heavy area of bright red with the spare, much larger, area of neutrals.

REPETITION

Repetition is a device we use for various purposes. Repetition of a color, for example, will often make your eye move from one instance of it to another. Your eye automatically connects, or associates like colors. We also use it to create unity; we relate two or more elements by sameness (as opposed to relating them by contrast). Repetition can create a sense of rhythm or movement in a piece, by moving your eye across the piece at various intervals.

However, repetition can also diffuse the power of a piece. You start repeating elements and pretty soon you have an all-over design with no particular focus. A big bright red splotch can be very eye-catching, for example, in a sea of muted or quiet space (see "It Could Be Anywhere," previous page). Repeat the red a few times and the original splotch loses its impact.

Consider repetition a device to be used carefully and mindfully. What are you repeating? A shape? A line? A color? A pattern? What counts as repetition? Can you make a piece with no repetition at all? How little repetition can you get away with? How much repetition, and of what elements, can you use and still have enough variety to make the piece interesting? This line of questioning comes down to how much or how little contrast you want, and in what areas. There is no rule or solution that works for every painting. Nor are there any particular guidelines. Repetition of some elements is just one aspect to consider in composition.

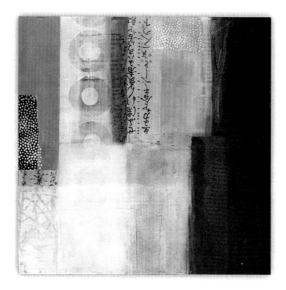

EDGE LOCATION #6, 12 x 12 IN.

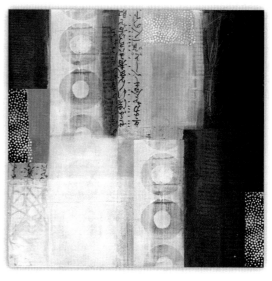

EDGE LOCATION #6, DIGITALLY ALTERED

The image on the left is the original piece. The one on the right has been digitally altered to include repetition of some of the elements: the trio of lifesavers, the small black rectangle with tiny white dots, and a bit of the red rectangle. To my eye, the altered version looks a bit busy, but it also looks over-balanced. To me, the lifesavers in the original piece are a strong element; in the altered piece they create too much symmetry, making the piece heavier and static.

MOVEMENT

Where your eye moves in a painting has a lot to do with visual weight. Visual weight refers to how much attention the various parts of your piece command. Where does your eye go first, and where does it go next? We'll discuss visual weight separately, but I want to address the issue of movement here.

Color is a very strong language, and your eye will often connect like colors, so it will move from one instance of red, for example, to another instance of red. Value is another strong language; your eye will connect elements of similar value, unless they are of very contrasting colors.

If you repeat every color in your piece, your eye might move all over the place. You need not repeat the color in exactly the same way or in the same quantity. Your eyes (the viewer's eyes) will do the connecting.

You can also create movement with line and gesture, with pattern, with directionality, and in many other ways. When you are looking at your art, pay attention to where your eye moves. Maybe it doesn't move at all, and maybe that is fine.

EVENT #3, 9 X 12 IN.

It is the scribbles in the piece that create movement, from lower left to upper right, because of their strong directionality. My eye is immediately drawn to the lower left, because it has the darkest value and the most intense scribbling.

BIO DIVERSE CITY #2, 18 X 24 IN.

My eye moves from the lower right to upper right, connecting the instances of red. The lines also contribute to a sense of movement, in that they are wandering from lower right to upper right.

FOCAL POINT OR FOCAL AREA

The focal area is the place in your painting where your eye is naturally drawn first. Glance at your painting for just a second, and what do you see? It is sometimes challenging to get this perspective on your own work, so I find it helpful to step back from it about ten feet, or else take a photo and view it on a screen. Then glance for just a second. Be honest about what you see. You may have intended for one area to be your focal point, but the piece may not agree with you. Seeing a focal point is about seeing your work, it is about observation. Your piece may have more than one focal point, that is, more than one area that catches your eye first. This can be confusing, or it can work. It depends on the individual piece, and you have to see it on a case by case basis. Not every piece needs a focal point. Some pieces rely on subtlety and allow the eye to wander in and around the painting. I suggest that you not get attached to a particular area as a focal point; that can make it hard to see your work neutrally. Allow a focal point to emerge, rather than forcing it, by paying attention to where your eye is drawn.

Visual weight is the degree to which an area or an element commands attention.

VISUAL WEIGHT

When you look at a painting, or a painting in progress, what do you see first? That's your focal point, or area of greatest visual weight. Where does your eye go next? Are there areas that command attention, but not as much as the focal point? Are there several areas that command attention equally?

I find it useful to think of visual weight in terms of distribution: is there one focal area or more? Is there "breathing room" (i.e. areas that command less attention)? Is there even or uneven distribution of visual weight? Looking at visual weight in an observational, or objective, manner, can help you decide how to go forward in a painting. There is no one right way that visual weight *should* be distributed. It depends on the individual piece and what you, as an artist, want to say.

Handling visual weight is an important skill in composition. You can create heavy visual weight in number of different ways depending on the context, but here are some guidelines.

The following characteristics are generally very eye-catching, or visually "heavy":

- ▶ High color contrast (opposites on the color wheel are highest in contrast of hue)

- ▶ High value contrast (black and white being the most extreme)

- ▶ Bright color, when the surrounding color is dull or neutral

- ▶ Dark value, if the surrounding areas are mid-value or light

- ▶ Active marks or scribbles, if the surrounding area looks more calm

BREATHING ROOM

"Breathing room" is also important to consider. Areas of relative "light" visual weight, spare, quiet, and not particularly eye-catching, can be important in contrasting with visually heavy areas. To create breathing room, leave areas of your canvas quiet relative to the main elements. Breathing room need not be blank or flat; quite the contrary: quiet space can have loads of subtle nuance and variation.

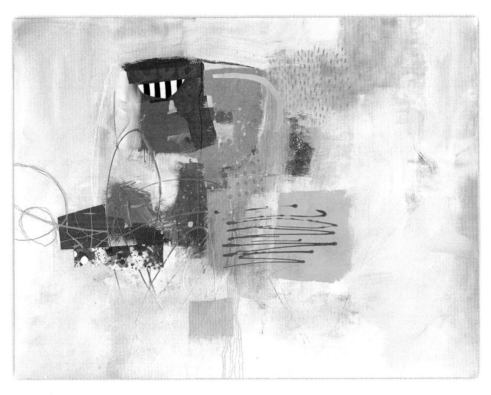

ALTERNATIVE FACTS, 19 x 25 IN.

This piece has a lot of breathing room surrounding an area of heavy visual weight, which consists of the brighter colors, active scribbles, and higher contrasts.

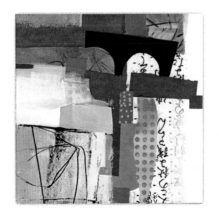

PATTERN GRID #7, 8 x 8 IN.

This piece has a greater proportion of visually heavy area than the piece above. The bright colors, patterns, and the black shape all form a focal area, while the off-white along the right margin and at the middle left constitute the breathing room or places for your eye to rest.

Compositional Formats

Traditional compositional formats—the grid, the abstract landscape, the cruciform, and so forth—can be helpful in providing structure for a visual exploration. For example, if I want to explore color and value in a series, and I want to keep it simple and straightforward, I may decide to use a grid structure for each piece in the series. This allows me to focus on color and value, and not have to re-invent the composition with each new piece. I establish a composition type and explore given variables within that.

You might investigate a compositional format itself, for example, an abstract landscape, and then explore variables within that given structure: try putting the horizon line in different places, dividing the space in various ways. I was admiring work from a number of different artists, that featured elements clustered in the center, with breathing room all around. I chose to explore that format, without specifying the elements or colors, just to find my own way with it.

Compositional formats are not ends in themselves. They are simply structures that you can invoke as starting points, or as descriptors when observing finished work or work in progress. You may notice, for example, that a piece you are working on suggests a cruciform or an abstract landscape or a grid. At that point you can choose to continue in that direction, emphasizing the format, or decide to take it in a different direction, or ignore it altogether. My point here is that compositional formats are not compositions. They are places that artists have "landed" in their visual explorations. Use them as tools if you find it useful to do so. Your work does not need to have a recognized format.

ABSTRACT LANDSCAPE

The *abstract landscape* is a format often characterized by a strong horizontal element that can be interpreted as a horizon line. Some abstract landscapes have elements suggestive of landscape features, such as rocks, cliffs, trees, bodies of water, etc. The piece itself does not have to be in a horizontal orientation; a vertical or square orientation can just as easily be an abstract landscape.

SPLASH #5, 12 x 12 IN.

is an example of an abstract landscape which has the strong horizontal element close to the upper edge. The spatters of paint, as well as the title, suggest a body of water such as a lake or ocean, with the horizon reading as shoreline.

Compositional formats can provide structure for visual exploration.

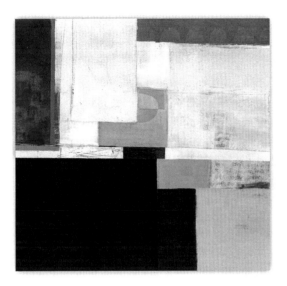

GRID

The grid is characterized by a strong vertical and horizontal orientation of elements. Even if the elements are circles or some other shape, they are arranged in more or less horizontal and vertical rows. Though I treat it as a separate structure, the grid encompasses other traditional formats, such as the abstract landscape, the cruciform, and stripes, in that these are also based on horizontal and vertical axes.

PAGES #1, 12 x 12 IN.

This piece is very clearly a grid, as most of its elements are rectangles in either vertical or horizontal orientation. The few exceptions - the gray arcade shape in the top right and the quarter circle and half arch in the upper center - do not detract from the strong grid format.

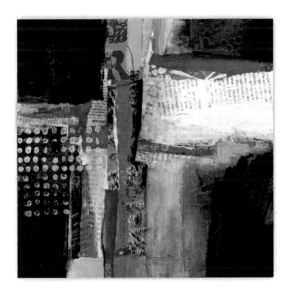

CRUCIFORM

The cruciform is characterized by four arms of a cross, each reaching the edge of the piece. The cross shape reads as the main positive image, while the four quadrants surrounding it read as negative space, or background. In this format, it is fun to play with variations in the four quadrants, with breaking up the cross shape into little bits of color and pattern, and overlapping elements that create transitions between the positive space and the background.

CRUCIFORM STUDY #1, 10 x 10 IN.

Though the four quadrants surrounding the cross shape are all deep gray and black, they vary in size and proportions. Each arm of the cruciform is different from the others, but tied together by color and pattern.

COMPOSITION

ALL-OVER FORMAT

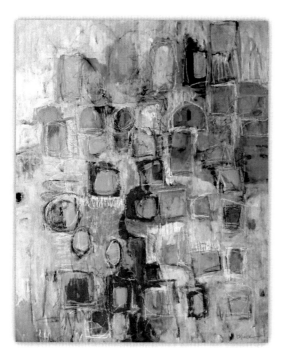

MEET ME AT 10, 30 x 24 IN.,
BY BETTY FRANKS KRAUSE

This composition is an all-over design or pattern, with elements of similar size distributed over most of the surface. I would call this an "all-over" format.

NO PARTICULAR FORMAT

The piece at right is based on no standard compositional format. Perhaps for that reason, it looks a bit chaotic and disorganized at first glance. But for me, it "works," on its own terms, as an expression of my personal artistic voice, as well as that of the materials and the process. Sometimes a little chaos or dissonance is part of what you want to express. It can be surprising and unpredictable to work without the structure of a tried and true format, but it opens new possibilities as well.

CENTRAL CLUSTER

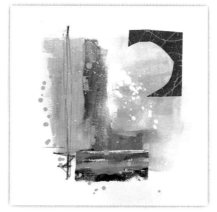

SPARE PARTS #4, 10 x 10 IN.

This is a composition format I call "central cluster," as all the main elements are clustered towards the center, with breathing room around the edges.

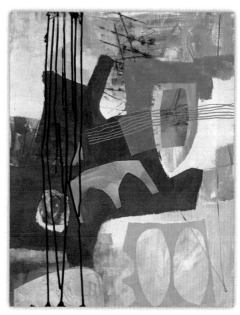

CHAOS THEORY #1, 18 x 24 IN.

No particular format is evident in this piece, which is one thing I like about it.

Common Issues in Composition

The compositional issues I see the most often in my students' work (and my own work if I'm not paying attention) are the following:

THE PIECE IS "TOO BUSY"

There are too many eye-catching areas ("focal points" or areas of heavy visual weight), all competing for my attention, such that the piece looks confused. A piece gets too busy if:

- ► You are trying to get too much into one piece
- ► You are afraid to cover up the pretty bits
- ► You are afraid of open space.

Paint over the pretty parts! Pare down the image to one strong statement. This is, of course, easier said than done, but this "editing" is an essential part of the process. Allow the image to emerge more clearly by cleaning up the clutter and allowing some breathing room.

THE VALUES ARE ALL SIMILAR

There are not dark areas or light areas, but all of the colors are in the middle of the value scale. This trap is easy to fall into if you are focused more on color and less on value. If the piece is not working, try extending the value range by darkening some colors and lightening others, or by painting over parts with very light neutrals.

THE PIECE IS OVER-BALANCED

Too many repeated elements or colors can make a piece look too matchy-matchy, or overly balanced (see p.64). A little repetition can go a long way, so if your piece is looking over-balanced, paint over some of the repeated elements, or parts of them.

ELEMENTS ARE VERY SIMILAR IN SIZE.

If you are not paying attention to scale, you can fall into the habit of making elements that are of a similar size. Increase the size of an element by painting or collaging a similar color next to it. Reduce the size of an element by painting over parts of it.

FIELDS OF COLOR #4, 12 x 36 IN.

This is an example of a "stripes" format. Within this seemingly rigid structure, I was able to explore color and texture, layering and line.

CHAPTER 4: LOOKING AT YOUR WORK

What is Observation?

What gets in the way of seeing your own work? When I ask my workshop participants to describe a piece of their work, they almost never respond by actually making observations. The most frequent answer is something about how the piece was made. "I started with the background..." for example. When I say that this is not observation but a description of process, the next place a student often goes is to describe the visual elements in terms of process or technique: "there are collaged pieces on the right and graphite lines on the left," for example, or even "there is a bright red ground, but it's all covered up". Again, this kind of statement is heavily dependent on the experience of having made the piece. Until I demonstrate exactly what I mean by "observation," a student will usually default to process and technique.

One possible reason that we default to a description of process is that we want to give ourselves credit for all the hard work we put into a painting, especially if we have obscured beautiful passages by building up many layers. The truth is that the surface of the painting IS the painting. There may be partial masterpieces under there, but the whole visual statement, as seen by anybody who looks at it (who doesn't know how it was made) is what counts when all is said and done. Ultimately, your painting has to stand on its own.

Another default is to criticize or evaluate the work or speculate on how it could be better. "It needs something over here," or "this part doesn't work," or "it would be better if..." Without actually making specific observations about *what is there*, the student is quick to say what is not there, or that it should be different in some way.

Observing your work is not describing the process.

Perhaps we default to criticism because when asked to observe, we DO observe, almost as if looking through another's eyes. Once the piece is out there in front of the teacher/colleague/audience, we may see it differently and suddenly see all that it is lacking. Or we deflect criticism from others by criticizing ourselves.

Sometimes I have a student say that they don't want to "analyze" their work, they just want to paint. Fair enough. But observations are simply observations; they do not require analysis in terms of what "works" or doesn't work, or why. If it is the light values and neutral colors that make the bright colors pop out, fine. But that kind of analysis can come after you have observed that there *are* light values, neutral colors, and bright colors.

OBSERVE VISUAL CONTENT

In the previous chapter, I describe composition of a piece as the 'totality of its abstract visual content.' When you are observing your work, whether in process or finished, you are identifying its visual content. What do we mean by visual content? Visual content consists of the elements, and their relationships to one another and to the painting as a whole, or the 'picture plane.' Everything that you see is visual content. Here are some questions you can ask yourself while looking at a painting:

▶ What elements are in my painting? How would I characterize those elements?

▶ Scale: are my elements all the same size? Similar? Big or small relative to the size of the page?

▶ Color: describe the palette; are the colors bright, muted, dark, or light? Is there a wide range of colors or limited palette?

▶ Value: do I have value contrasts? Are they subtle or dramatic? Do I have a wide range of values or a narrow range?

▶ How about texture, transparency, and opacity? Is there texture all over? Some texture and some flat color?

▶ How do my elements relate to the edges of the page? Do they touch the edge? Hover away from the edge? Overlap it?

▶ Do my elements crowd the page? Is there breathing room?

▶ Are my elements all clustered together? Spread evenly or unevenly?

▶ What draws my eye first? Is there one focal area or more than one? Is it confusing to look at?

▶ How is the visual weight distributed?

▶ How is the space divided?

▶ Do some elements appear to come forward and others to sit back?

You will probably develop your own set of questions that are tailored to your particular work, but these might serve as a starting point. You describe the elements, and then describe how they relate to one another and how they relate to the piece as a whole and to the edges of the painting. If you answer these questions (and others) as straightforwardly as possible, you will come up with neutral observations about your work.

Composition is the visual content of a piece.

I have made a number of observational statements about the two pieces at right. These are not exhaustive lists, covering everything I see. They include the things that stand out most to me. The act of making observations makes me see more clearly. Already I am seeing things in these pieces that I had not noticed before. In Color Pattern Line #2 I had not noticed that the two pink painterly shapes are almost identical in size. In Submerge #6 I had not noticed that the two shapes on the left are a very similar distance from the edge of the piece. If these pieces were still in process, those are things that I could consider changing. The pieces speak to me as they are, (which is how I define them as finished), so there is no reason to change them. But moving forward in either series (I always work in series), my observations can suggest variables I might explore.

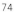

- This piece is dominated by pinks and oranges, with a large swath of white veiling on the right, and a little bit of gray mass on the left.

- There is a large orange outline oval that takes up most of the right half. It touches the top edge.

- A highly contrasting blue dot pattern in the lower right appears to run off the bottom edge of the page; it overlaps the orange outline oval.

- A small red shape in the center left has ragged edges; it provides high contrast with the gray on its upper edge and has much more subtle contrast with the pink and burnt orange. There are two deep pink painterly shapes of equal size, to the right of the small red shape. All three are connected.

- Fine line scribbles overlap the orange oval, the red shape, and much of the left part of the ground.

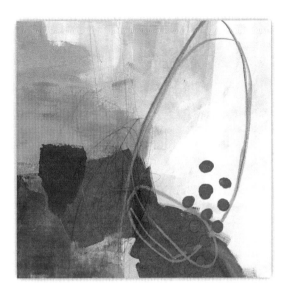

COLOR PATTERN LINE #2, 10 x 10 IN.

- I see three ovoid shapes dominating this piece, varying in proportion and somewhat in size.

- Two shapes on the left are close to the left edge; the bottom shape overlaps the bottom edge.

- The piece is dominated by earthy and neutral colors.

- The space is divided into unequal quadrants by a vertical division to the left of center, and a horizontal division above the center. Color and value contrasts make up the divisions.

- The darkest value is in the lower center. The lightest values are in the top-most shape and the top right quadrant.

- Most of the piece has a lot of texture, though the top left corner is a flat gray.

- The smallest shape is just above the center of the piece.

- I see lines and scribbles within the shapes and in the upper right quadrant, veiled and revealed to various degrees.

SUBMERGE #6, 20 x 20 IN.

Observing your own finished work helps you to see it as the viewer, rather than as the maker of the piece. This can help you move forward, or expand your vocabulary, in your art practice. Observing your work exposes your habits, your defaults, which can then suggestion alternate avenues of exploration. For example, if I notice that I tend to have my elements clustered in the upper left quadrant, I might try leaving open space or breathing room in the upper left quadrant. If I observe that I tend to use mostly mid-range values, then that suggests that I could try using more dark values or light values. Some of what we tend to do, habitually, is part of who we are as artists. Our default mode is part of our signature "style" or visual voice. However, noticing your habits and tendencies allows you to make conscious decisions about whether and where to expand. Your voice will always come through, even if you do not see it at first.

Observing works in progress helps you move forward on individual pieces and series.

While you are painting, you don't want to be nagged by an inner voice making constant observations. But if you can periodically zoom out, and look at your work, a few neutral observations can suggest options for moving forward. If you never get stuck on a painting, and you always know intuitively what to do next, then perhaps this kind of observation is superfluous. For most of us, though, observing the work in progress, as a whole periodically can be helpful. You need to get occasional distance from it. Sometimes it is helpful to take a photo of your work in progress and view it on your tablet or computer screen.

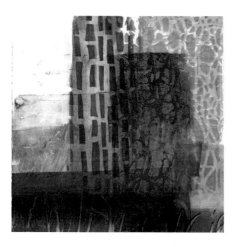

This work in progress is a monoprint using a gel printing plate with Golden OPEN acrylic paints.

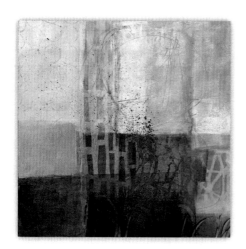

GRID PRINT #6, 12 X 12 IN.

The piece on the top left is a work in progress. What I observed was a lot of bright, mid-value color; some dark values in the center and at the bottom; a distinct grid format; lots of pattern; and transparent colors. Thinking in terms of contrast, I decided to add light, opaque, neutral colors. I saw that the deep earthy brown in the center was very similar to the dark value at the bottom, so I obscured the central dark value. Now the dark values at the bottom read more clearly to me. Likewise, having covered over much of the bright colors, the ones that are exposed are stronger because of the contrast with neutral grays and off-whites.

OBSERVE YOUR EMOTIONAL RESPONSE

Another important observation, besides the visual content, is your gut response to the piece or to parts of the piece. In observing what I'm calling your "emotional response," it is important *not to think about it.* Otherwise, you get a second-hand version, possibly filtered through what you *meant* to paint, or what you think you *should* feel. Your gut response is your immediate and unfiltered feeling. Cumulatively, it reveals who you are as an artist, and individually it informs your direction on a particular piece. This is where your artistic voice will develop when you pay attention to what *you* find compelling. You need not even give words to your response, just notice that you *do* respond. It can be as simple as "this thing feels right," or "it feels like something I want to take further," or the less verbal "Ooooh," "YUM!," or "Eeeewww." What jazzes you, compels you, makes you say "YES!" to the image, that is your compass that will set the direction of your work. Paying attention to this and trusting it takes practice. Letting go of the thinking and evaluation, and letting go of how-you-made-it are important skills in observing your work and observing your responses.

Your gut response reveals who you are as an artist.

Here are a few examples of observations that express emotional response:

► This part sets my teeth on edge.

► I find the color very calm.

► I love the way those two colors fight with each other.

► The piece has a bold and raw quality.

► This part looks like it is threatening to squash these little shapes.

► I love the tension of that line just almost-but-not-quite touching this shape.

Practice trusting your emotional response.

77

OBSERVE PERSONAL REFERENCES

Do you see any references to subject matter in your work? For example, does it look like a landscape or a face? When you share your abstract work with others, do they see something different? One thing I love about abstract images is that they are so open to interpretation. The viewer plays a vital role in the expression of the image by bringing his or her own sensibility to it.

Some artists use titles to suggest specific reference. The title can give you a hint of what the artist sees in the work, but it does not mean that the viewer may not see something different. The painting can be like a Rorschach test, suggesting as much about the viewer as the work itself.

The piece at right suggests to me shallow water, rocks, some movement, and shifting. I gave it the name "Tidal Current" to reflect that. However, *while I was painting it* I had no idea what it might suggest. Seeing something in your finished painting is not the same as beginning with a specific reference in mind. In abstract painting, I think it is important to be open to the possibility of specific reference without forcing it.

Seeing something in your finished painting is not the same as beginning with a specific reference in mind.

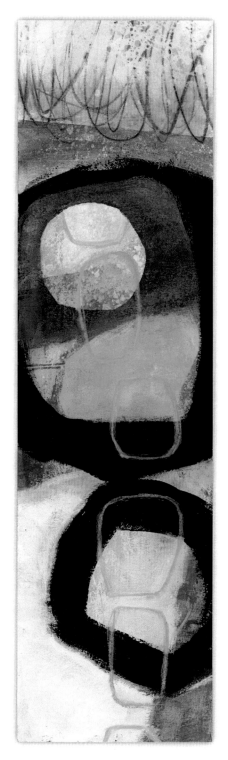

Tidal Current #1, 6 x 22 in.

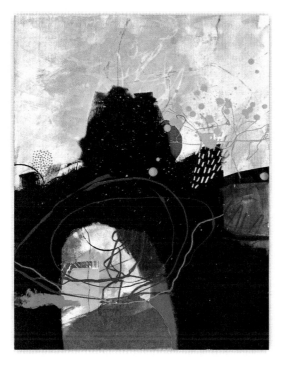

WAKE-UP CALL #2, 18 × 24 IN.

This piece evokes in me a sense of danger or alarm. Maybe it is the yellow that reads as fire, or the splatters that read as raining sparks. My response to it is more emotional than referential. Yet while working on it I was simply focused on the abstract elements and on the process. My thoughts were something like: "*how about this line over that color; oooh! Fun to splatter yellow over the black!*" It is only after I call it finished that I have a more general response to the piece as a whole. Or maybe it is that response that signals the piece is finished.

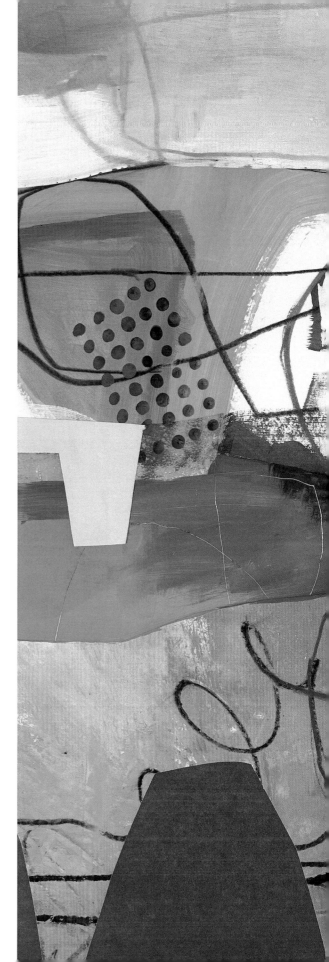

A NOTE ON MATERIALS

This book is not about materials and techniques; the studies or instructions are given in terms of visual content, and techniques are left fairly loose. However, I would like to spell out some basic information on the materials that I use most often, and answer some of the most common questions that come to me about them.

Paint

I use acrylic paints, so most of the pieces you see in the book are made primarily with acrylics. There are a few important characteristics of acrylics that often get confused or conflated. I will try to clarify these below.

VISCOSITY

The viscosity of paint refers to its consistency, how thick or how fluid it is. In general, heavy body paints are viscous, about the consistency of joint compound or peanut butter. They generally hold the texture of a brush stroke to some extent. Heavy body paints generally come in tubes or jars. Fluid acrylics are usually about the consistency of heavy cream; they pour easily, and they don't hold the texture of a brush stroke. I generally use fluids for smaller works, and heavy body paints for larger work, but there is a lot of crossover too. Golden Paints makes a line called High Flow Acrylics, which are the consistency of ink or liquid watercolor. These are more fluid than the fluid acrylics and are great for spattering or dripping. The viscosity of paints will vary from brand to brand, so you can find many consistencies in between these three basic types: heavy body, fluid, and High Flow.

TRANSLUCENCY AND OPACITY

The degree of clarity of a particular paint depends on a few things: in a high-quality brand of paint, the translucency or opacity depends on the specific color. The qualities of the pigments themselves are imposed on the paint, as there are no additives to influence its translucency. For example, pyrrole red is opaque, while quinacridone red is translucent; napthol red is somewhat translucent. This variation in translucency is due to the particular pigments that make those different reds. Some paints (usually of a lower quality, but not always) have additives that give them consistent characteristics in terms of translucency. For example, Blick Matte Acrylics are not only all of a matte finish, but they are also consistently opaque. How do you know if a paint is translucent or opaque? GOLDEN puts a swatch of the actual paint on the label, over three black slashes. The degree to which you can see the black slashes through the paint gives you an idea of translucency. You can make this kind of indicator for any of your paints (see page 51).

Do not confuse opacity with viscosity.

PHOTO: GEORGE BOURET

PIGMENT LOAD

The volume of pigment, relative to acrylic binder (and additives, if any) is the *pigment load*. High-quality paints have a lot of pigment in them, generally, while student grade and craft paints have less. The amount of pigment, to a large extent, determines the price of the paint. It is not the only factor in creating high quality paint, but it is an important factor. High quality paints can be extended with acrylic mediums, or tinted with white, and still retain their strength of color. For some applications you don't necessarily want the very high pigment load of a professional quality paint, so you may substitute a student grade paint, which is not only cheaper, but it saves the time of extending paint with medium.

THESE CHARACTERISTICS ARE SEPARATE

I often hear an artist or student saying something like: "The fluid acrylics seem to be more transparent," or "craft paints are more opaque," or in some way conflating two characteristics of acrylic paints as if they always go together. They don't. Some fluid acrylic paints are opaque, some are translucent, some have high pigment load, others do not. Heavy body paints can be opaque or translucent, highly pigmented or not.

Acrylic Mediums

There is a host of different mediums you can add to your acrylic paints to affect the viscosity, the drying time, the texture, or simply to extend the paint. The mediums I use most are acrylic matte medium (mostly for collage) and acrylic glazing medium or glazing liquid. Glazing liquid dilutes the paint, and also extends the working time: paint dries more slowly when mixed with glazing medium.

Drawing Tools

CRAYONS

I use water soluble crayons in my work for drawing and mark-making. Caran d'Ache NeoColor II is my brand of choice, as they are readily available and come in a huge variety of colors. When I am satisfied with my mark, I apply a very gentle coat of acrylic matte medium to "fix" the crayon. Then I can paint or collage over it without it bleeding. If you want to use oil pastels in your work with acrylic paint, use them last. Acrylic over oil does not adhere well, and it will eventually peel off. The water soluble crayons do not form a perfect bond, but it is better than that between oil pastel and acrylic.

GRAPHITE

I keep a selection of graphite in the studio for making marks. Graphite "crayons" are great for mark-making; the non-water-soluble graphite I find the most useful, as it is hard to control the smudging with the water soluble ones. Some types of graphite drawing tools smear, so test them before using them in your work. To control smearing, use the matte medium method described above; if you need an even gentler method, spray first with fixative, and then apply the matte medium.

PHOTO: GOLDEN ARTIST COLORS, INC.

MARKERS

I don't use ordinary markers in my work because I generally want opacity in my drawing materials, and markers tend to be translucent. I've found that paint markers vary a lot in quality and user-friendliness. Many people like the refillable paint markers, filling them with Golden's High Flow acrylics. That's a bit too fussy for me. Uni-Posca Paint Markers are my favorite, as they are opaque, and the tips don't dry up. I also use Pitt Pens or Micron Pens for very fine lines. Even though paint markers and the pens I mention are meant to be permanent, I do find that it's better to coat them with matte medium as I do with the crayons and graphite. Make sure the marks are completely dry first.

Substrates

PAPER

For most of my smaller work, I use a smooth printmaking paper made by Stonehenge. It is 250 gsm (grams per square meter), which is slightly heavier than a 90# watercolor paper. I choose a smooth paper because I want to be the author of any texture that shows up in my work. This paper is suitable for works up to around 12"x12," unless the pieces are to be mounted on wood panel (see below). For larger works, I prefer 300 lb (640 gsm) hot press watercolor paper. Hot press is the smooth surface.

I keep reams of 'cheap drawing paper' available for doing studies, lifting paint, off-loading excess paint, making collage papers, and more. The 80#, 9"x12" White Sulphite Drawing Paper from Blick Art Materials serves this purpose perfectly, but you could just as easily use 8.5"x11" heavier weight copy paper or something comparable. Having loads of cheap drawing paper makes me feel free to try anything at any time. I use the 18"x24" cheap drawing paper as well, for larger experimental work.

WOOD PANEL

I use cradled wood panels for mounting smaller works on paper. Wood panels are also great for working on directly. Apply a couple of coats of gesso to the top surface of the panel, and protect the sides with either painter's tape or a coat of matte medium. After finishing a piece on panel, I usually paint the sides with matte black acrylic. You can finish them with varnish, or apply matte medium, or continue your painting around the edges (like a gallery-wrap), but the sides should be finished in some way, so they don't absorb moisture.

MOUNTING PAPER TO WOOD PANEL

In order to provide a little wiggle room when mounting works on paper to panel, I cut my paper a quarter inch larger than the panel. When I work on 10"x10" pieces, I cut the paper to 10.25"x10.25". Apply a coat of PVA glue to the surface of the panel, then lay the artwork down so that it overhangs the edges of the panel on all sides. Use a bone folder or credit card to squeegee out any air pockets. Remove excess glue (if any), and then weight the piece. Place a sheet of wax paper or parchment over the surface of the artwork, then place over that a larger cradled panel or comparable surface. Put heavy books or a gallon of gesso on that for weight, and let it sit overnight. Use a sharp craft knife to cut the edges of the artwork flush with the sides of the panel.

PHOTO: DOG ON A BOAT STUDIOS FOR HUDSON RIVER VALLEY ART WORKSHOPS

ABOUT THE AUTHOR

I am a full-time artist working in acrylic paints, drawing media, and collage. I offer workshops nationwide and online, helping people to find a personal and playful approach to art making. I am most complimented when someone tells me that my work inspired them to try something new in their own art.

I began my career as a potter in the early 1990's, selling my tableware at craft shows and galleries. My pottery was very colorfully painted, and I realized that it was the painting and design that interested me most. In the early 2000's I transitioned into licensing those designs to product manufacturers, and thus began a career as a freelance artist. I had always done fine art on the side - painting, monoprints, and drawing – and in 2009 I gave up the competitive and uncertain world of freelance art in favor of teaching workshops and focusing on my own work.

I realized that I did not really know who I was as an artist. My work had always been subject to the needs of outside demands - for sale, for a commercial product, or as instructional examples - and I wanted to know what happened if I just made art as a personal inquiry. I still want to know, and it is that ongoing quest that keeps me motivated.

I love teaching, and it is integral to my work as a painter. I feel like we are all on this journey together, continually discovering what is inside us as artists.

ARTISTS' STATEMENT

Color, line, shape, pattern, texture, and depth: these formal elements are my foremost source of inspiration. It is after the fact that I connect my visual vocabulary to specific features of my experience. I see landscape, coastline, worn surfaces, rocks, and tides. I try to throw together contrasting elements, as if they washed up on the beach in a random arrangement, and then see how I can relate them to one another in a way that surprises me. I leave my paintings open to interpretation by the viewer, and I hope you will have fun looking at them!

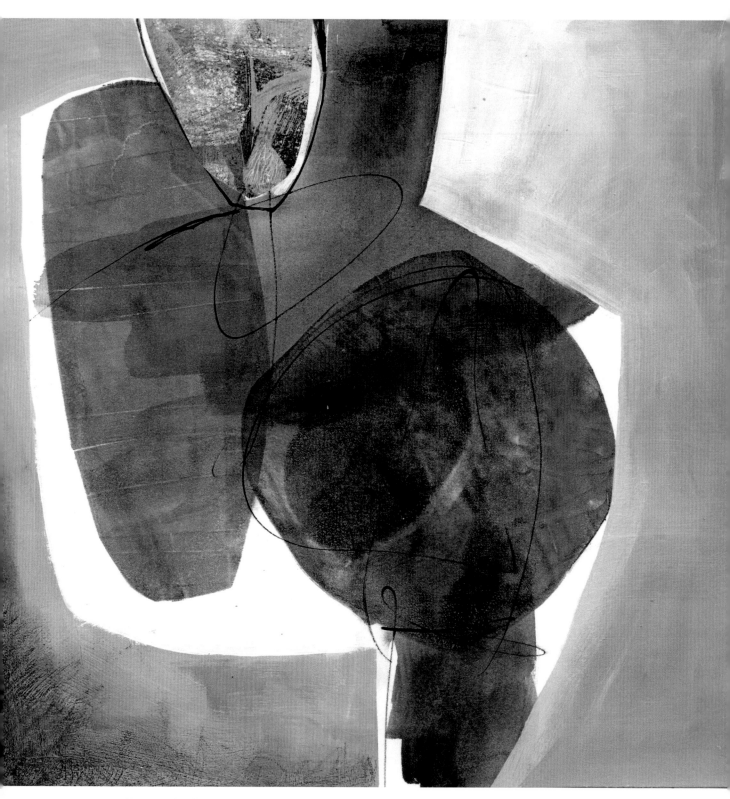

VESSEL #2, 10"x10" IN.

ACKNOWLEDGEMENTS

I would like to thank all my students, who have been a great source of inspiration and who have challenged me to hone my teaching skills. Without their insightful questions and honest feedback this book would not be possible. Irene Cole has been a terrific designer to work with, establishing the basic design of the book and then coaching me on the process as well. George Bouret did the photographs of me in the studio. Susan Sheehan, who has helped me administratively in my teaching business, has been a great sounding board in addition to her role as proof reader. My husband, John La Vecchia, also contributed his excellent proof reading skills to the project, and his moral support. Thanks to Naomi Linzer for creating the index. I am grateful to the artists who contributed their work to the book: Sheila Arora, Andrea Bellon, Lucie Duclos, Betty Franks Krause, Susan McCollum, and Suzanne Siegel. Lucie also contributed to the design, and coached me in the process of self-publishing.

INDEX

Page numbers in italics indicate illustrations.

INDEX

INDEX

INDEX

BLACK AND WHITE #12, 9x12 IN, BY SHEILA ARORA

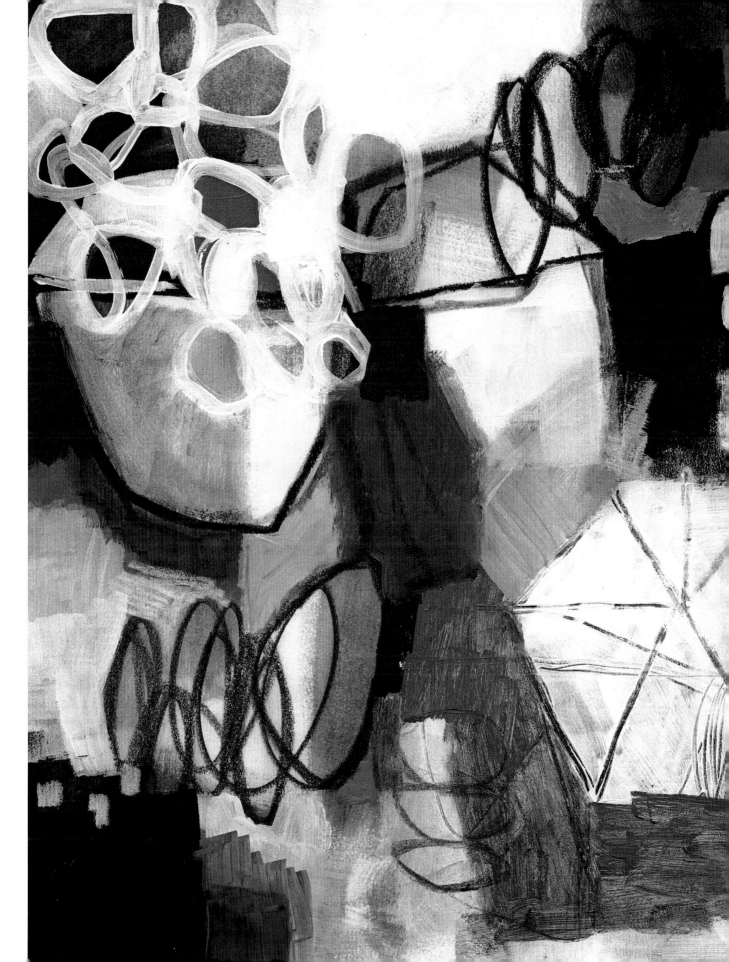

First Edition

© 2017 Jane Davies

Published in the United States by Jane Davies Publications

Design: Irene Cole and Jane Davies
Proofreader: Susan Sheehan and John La Vecchia
Indexer: J. Naomi Linzer Indexing Services

Manufactured in U.S.A.

ISBN 978-0692619803

Made in United States
North Haven, CT
04 September 2023

41132917R00055